BURY CORPORATION TRANSPORT

DAVID BARROW

Acknowledgements

My special thanks must go to the late Tom Fish, a driver at Bury for close on thirty-years, who provided me with a detailed fleet list and who on many occasions over the years shared his vast knowledge of the various vehicle types that Bury operated. And most of all, my thanks go to the photographers, as without their photographs this book would never have been published. Their name are as follows: Wally Talbot, the Ribble Enthusiast Club Collection, Sylvia and John Jones, Roy Marshall, the GEC Collection courtesy of David Beilby, W. J. Haynes, Alan B. Cross, Robert Mack, Travel Lens, J. S. Cockshott, S. White, Transport Images, A. J. Douglas, Alan Cawkill, Charles Rope, Bus and Rail Images, Yorkshire Transport Images, Peter Sykes, Steve Kelly, Harold Peers, East Pennine Transport Group and Bury Chess Club/Bury Times. Thank you also for the help I received from Wendy Gradwell at the archive department at Bury Public Library, and for granting me permission to delve through the minutes of the monthly Transport Committee meetings. Finally, to all the other photographers it has proved impossible to trace, my sincere apologies.

First published 2023

Amberley Publishing
The Hill, Stroud
Gloucestershire, GL5 4EP

www.amberley-books.com

Copyright © David Barrow, 2023

The right of David Barrow to be identified as the Author of this work has been asserted in accordance with the Copyrights, Designs and Patents Act 1988.

ISBN 978 1 3981 0770 0 (print)
ISBN 978 1 3981 0771 7 (ebook)

All rights reserved. No part of this book may be reprinted or reproduced or utilised in any form or by any electronic, mechanical or other means, now known or hereafter invented, including photocopying and recording, or in any information storage or retrieval system, without the permission in writing from the Publishers.

British Library Cataloguing in Publication Data.
A catalogue record for this book is available from the British Library.

Origination by Amberley Publishing.
Printed in the UK.

Introduction

Bury's first ever tramway was launched in the town on 12 March 1883. Powered by steam, it was operational for the next twenty years, until 5 June 1903, when the first scheduled journey by an electric tram took place from Moorside to Jericho. The first motor buses came in 1925 in the shape of three Leyland single-deckers. It is reported that from then plans were in place to gradually replace all existing tram routes with buses but following the outbreak of the Second World War in 1939 total abandonment was not achieved until 13 February 1949.

From 1925 until 1933 a variety of different types of buses were acquired, both new and second-hand. Then from 1935 onwards Leylands became the number one choice for new deliveries, with a small number of AEC, Daimler and Guys added, but in 1964 they changed their allegiance to Daimler. From the late 1940s Weymann was to become the preferred choice for bodywork. But in 1964 the undertaking had a brief flirtation with bodywork by Walter Alexander in Falkirk, before standardising on the East Lancashire Coachbuilder Blackburn for the last five years of their existence.

Although Bury Corporation Transport was only a medium-sized operator (less than 100 buses), it did lead the way in a number of their bus purchases, though not all were wise decisions.

Bury was the only Lancashire municipal with the three-axle Leyland Titanic, the Guy Wulfrunian, and Alexander-bodied Daimler Fleetline. In 1946, Bury became the first operator in the UK to place in-service Leyland Motors' first new post-war double-decker, the Titan PD1.

The end came in November 1969 when they joined forces with ten other Lancashire and Cheshire municipal bus companies to form South East Lancashire and North East Cheshire PTE (SELNEC) with a combined fleet of 2,500.

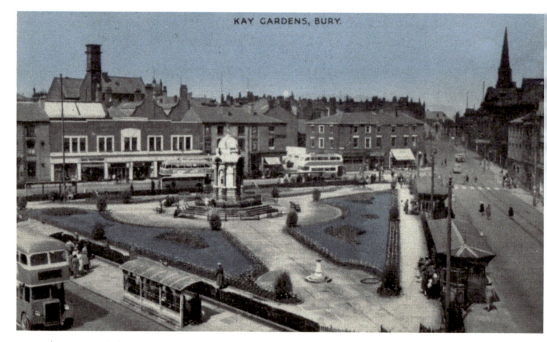

This postcard shows Kay Gardens in Bury town centre in the mid-1950s. The garden's triangular shape acted as the main area for all of the town's bus services. (Courtesy of Sylvia and John Jones from Nelson, Lancashire)

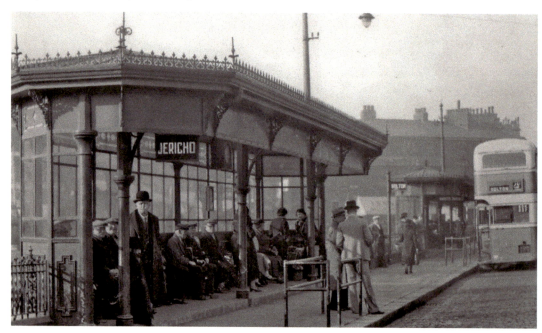

This view from 1938 shows one side of the gardens and the cast-iron bus shelter, which was sadly pulled down and sold for scrap at the beginning of the 1980s when the new bus/rail interchange opened. The bus on stand waiting to leave for Bolton is a Rochdale Corporation Transport AEC Regent – English Electric 122 BDK 207, new in 1936.

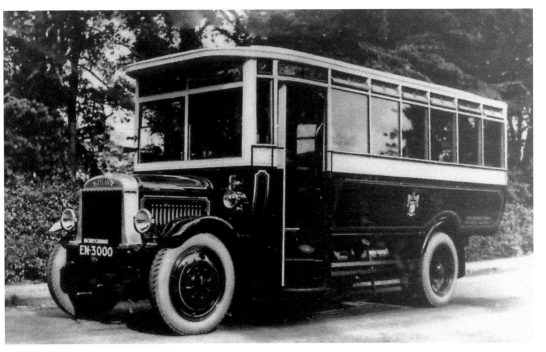

Bury's first buses came in 1925 when five new Leyland C7 single-deckers were bought. Two, including this one (EN 3000), did not arrive until 1926.

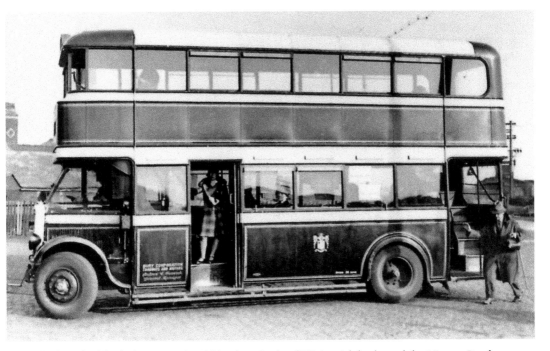

The first double-deckers came in 1930 – four Leyland TD1s with bodywork by Massey Brothers of Wigan. This is the last one to be delivered. All four had petrol engines, which were converted to diesel in 1936.

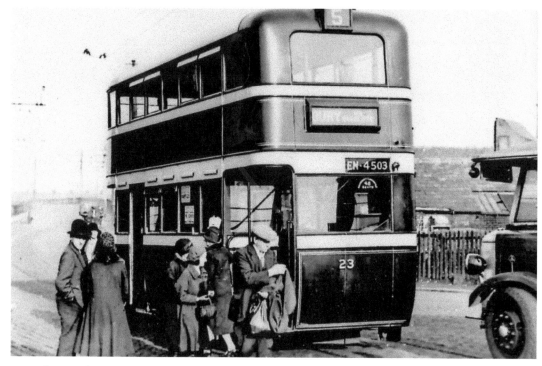

The same bus – 23 EN 4503 – was withdrawn in 1945.

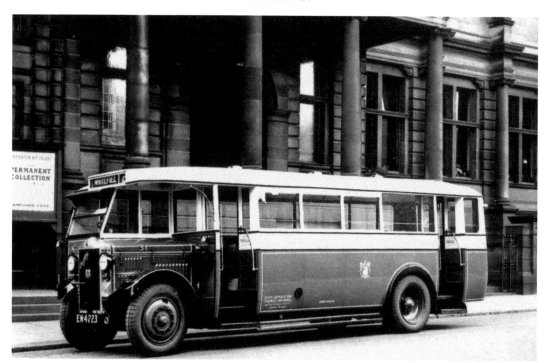

1930 also saw the arrival of a Crossley Alpha Vulcan single-decker. 31 EN 4723 is seen outside the town's art gallery in Moss Street.

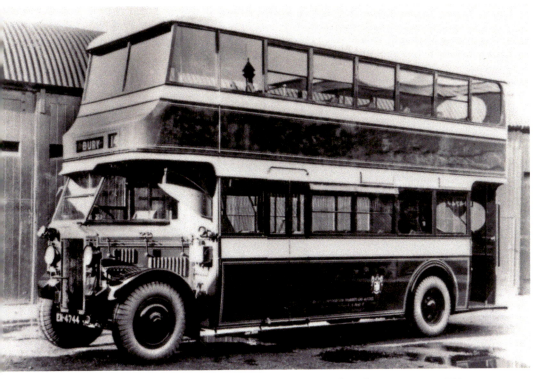

At the Brush factory in Loughborough is a Crossley VR6 Condor of 1930, 28 EN 4744.

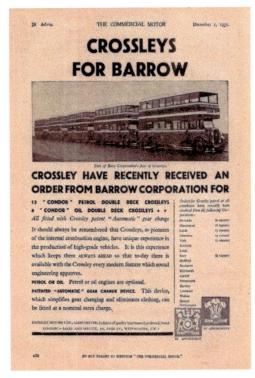

This Crossley Motors' advert taken from the *Commercial Motor* magazine of December 1931. It shows a line-up of new Crossley double-deckers destined for Bury.

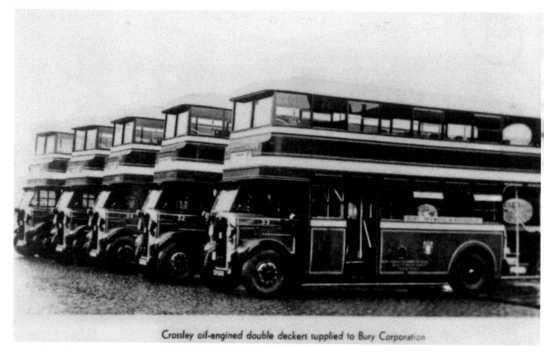

Another five Crossleys for Bury.

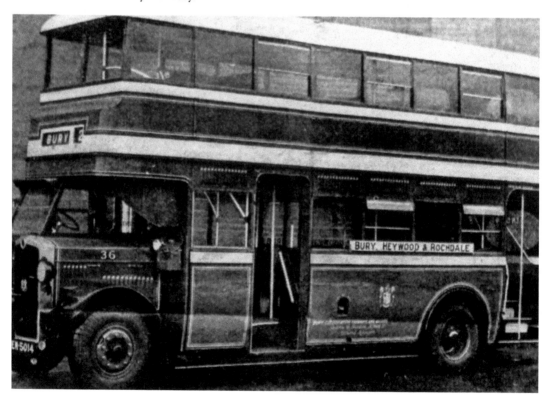

1931 Crossley Condor 36 EN 5014 was withdrawn in 1944.

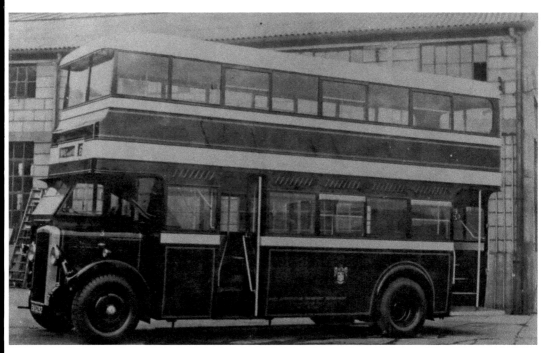

3 EN 5292A, a 1932 Daimler CP6 with Strachan's forty-eight dual-door bodywork.

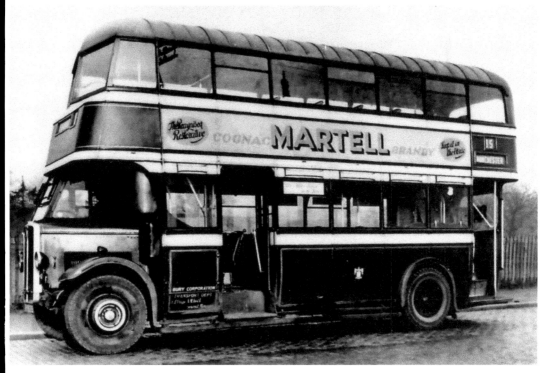

This dual-door AEC Regent-Roe is one of eight new in October 1933. All were converted from two staircases to one in 1944.

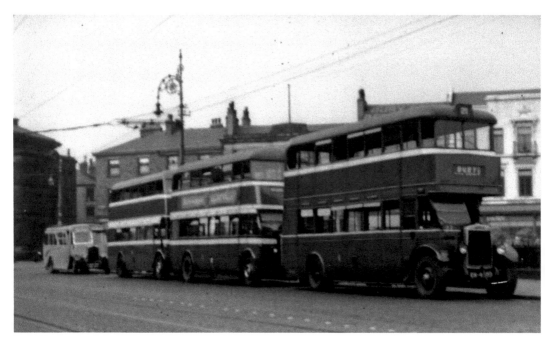

A view of Kay Gardens in the mid-1930s. A Massey-bodied Leyland TD1 plus an English Electric TD3, a nearly new Leyland-bodied TD4C and an unknown coach bring up the rear.

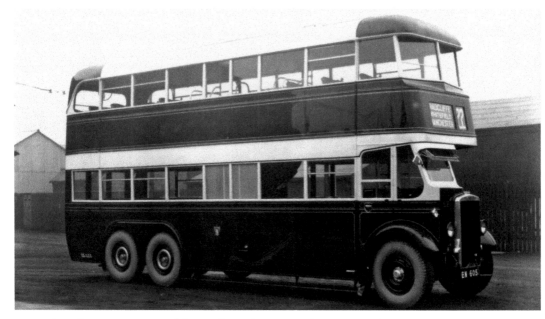

When the trams were withdrawn from the Moorside to Jericho line in January 1935, five three-axle Leyland Titanics fitted with a centre entrance/exit and sixty-seat English Electric bodywork were purchased for the service. The reason given for buying these buses was that at the time passenger capacity was nearest to the trams. All were withdrawn from service in 1945. The following three photographs show the English Electric Preston factory before delivery to Bury. At 30 feet long, they had two driven rear axles.

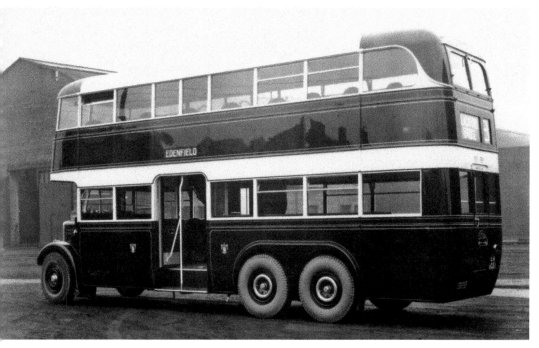

Showing the use of single-tyre rear wheels.

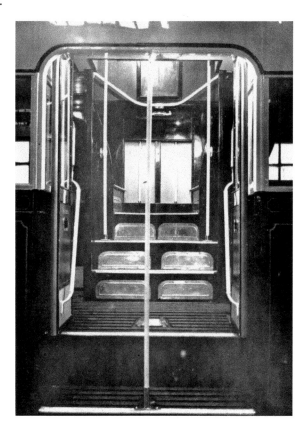

The entrance (no platform doors) leading to the double staircase.

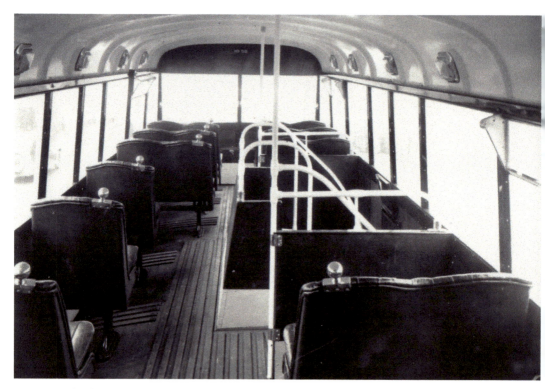

Note the double staircase and the single-skin roof.

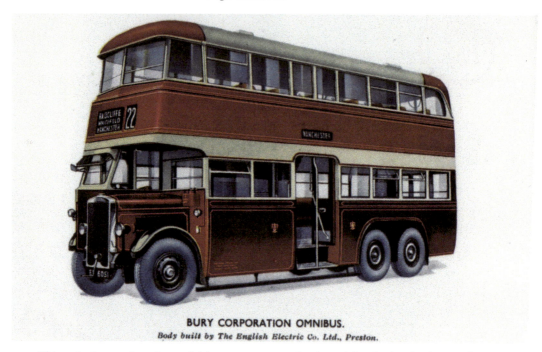

BURY CORPORATION OMNIBUS.
Body built by The English Electric Co. Ltd., Preston.

This artist impression gives a fairly accurate reproduction of the shade of red Buy's fleet was before 1944, when it was changed to green.

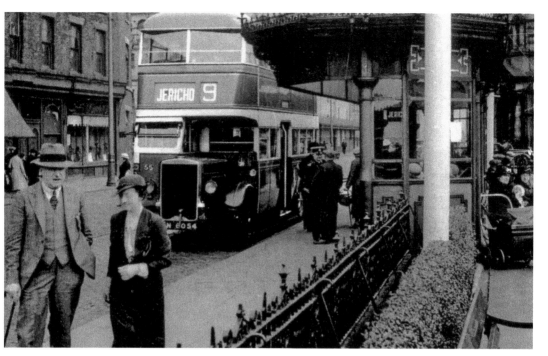

A former employee told me that the two people in the foreground were in fact a local doctor and his wife taking an afternoon stroll in the summer of 1935. Leyland Titanic 55 EN 6054 is about to depart on the 5-mile round trip to Jericho.

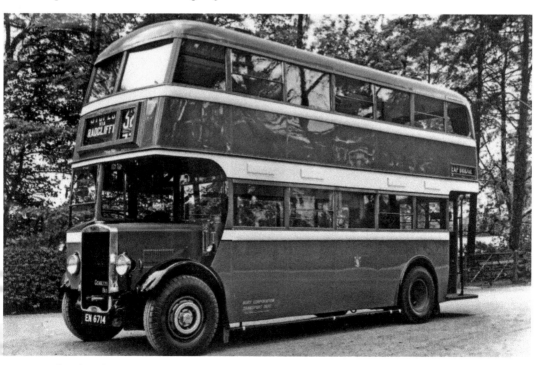

An official Leyland Motors photograph of a 1936 TD4C 58 EN 6714.

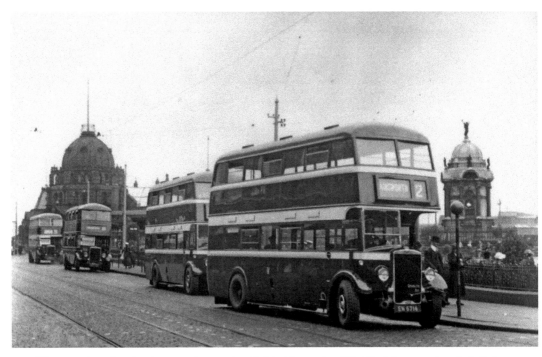

The same bus shortly after entering service. Behind is another TD4C of the same batch. A Bolton Corporation 1934 Leyland TD3C with bodywork by Bolton builder Bromilow & Edwards. A Bury Titanic is at the rear.

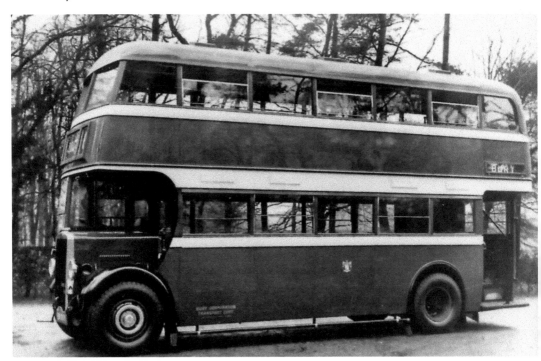

A 1937 Leyland-bodied TD4C, 31 EN 6971.

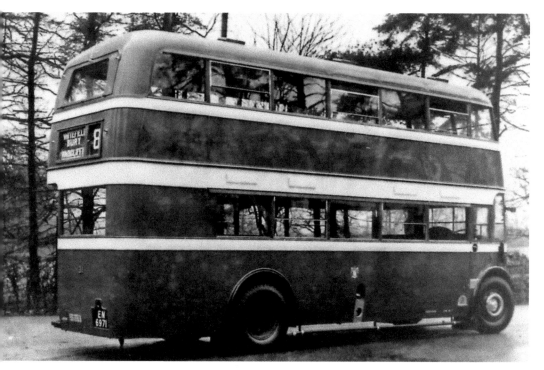

Rear view of the same bus.

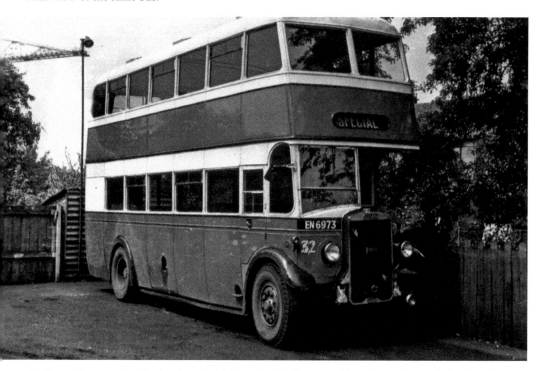

Ex-Bury Corporation Leyland TD4C 35 EN 6973. It was sold to Paton Bros of Renfrew in 1958. It was numbered 32 in this Scottish operator's fleet.

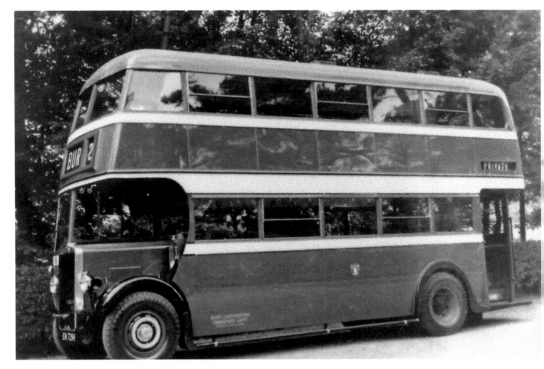

66 EN 7294, a 1938 all-Leyland TD5C.

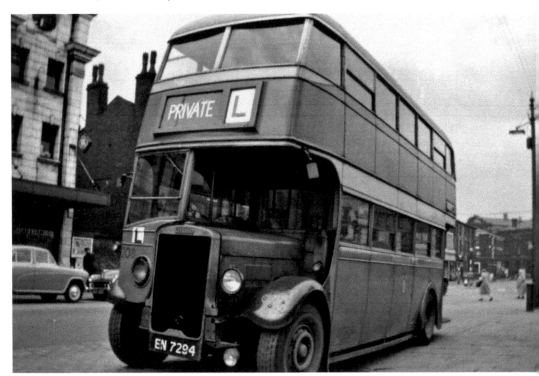

The same bus was withdrawn in 1950 and used as a driver training vehicle until 1958.

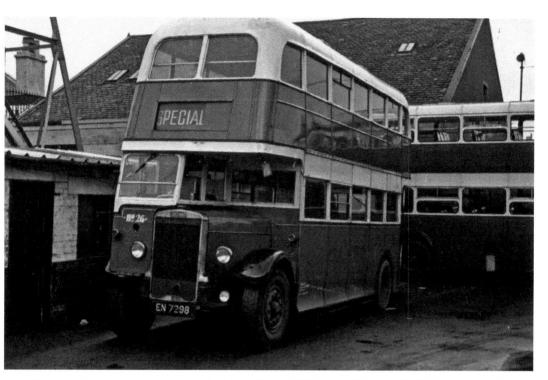

Number 26 in the Paton Bros fleet is this ex-Bury 1937 Leyland TD5C, EN 7278. It originally had Leyland bodywork, but due to a fire at the depot in August 1942 it was fitted with a new Northern Counties body in 1943. This was also the first bus to be painted in the Corporation's new green and primrose livery.

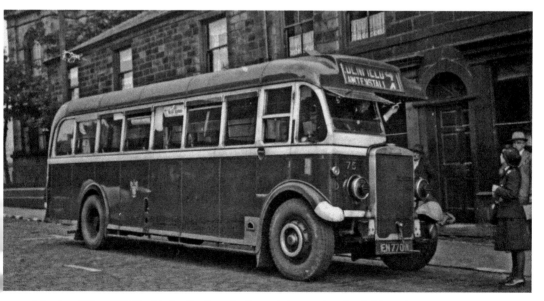

A Leyland Tiger TS8C with Burlingham bodywork is seen in Edenfield on the service 4, Bury to Rawtenstall. 75 EN 7703 was new in 1938. This view was taken during the Second World War, complete with headlight masks and white-painted front mudguard edges.

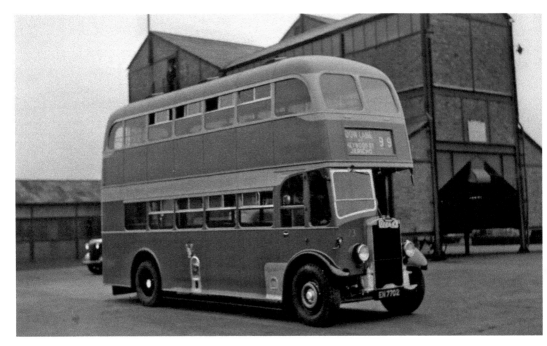

Unable to sell these Burlingham single-deck buses in 1951, the company decided to remove the bodywork and upgrade the chassis to TD5 specification and have all four rebodied as double-decks by Massey Bros of Wigan – a cost of £1,675 per bus. The first one to be completed, in November 1951, is photographed here at Summersales Colliery in Wigan. It was a drift mine and closed in the early 1960s. New buses went there to be weighed.

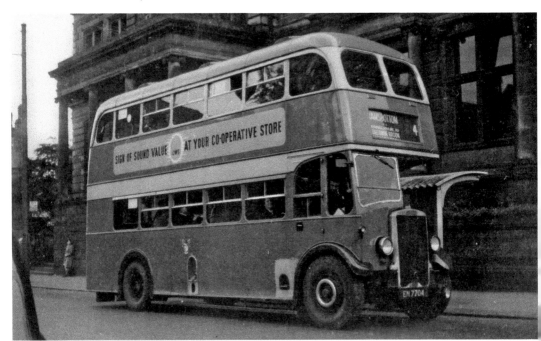

Another of the rebodied single-deckers is seen outside the art gallery in 1957 – 75 EN 7704.

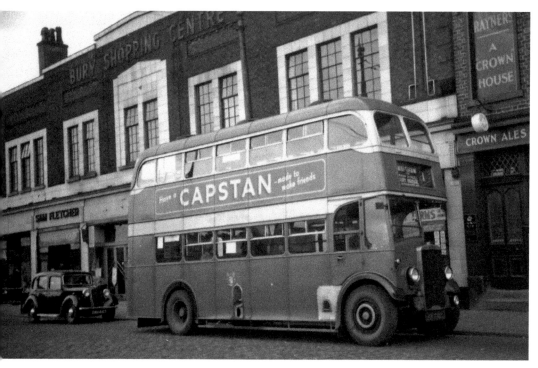

74 EN 7703 at the only bus stop across from Kay Gardens in 1953.

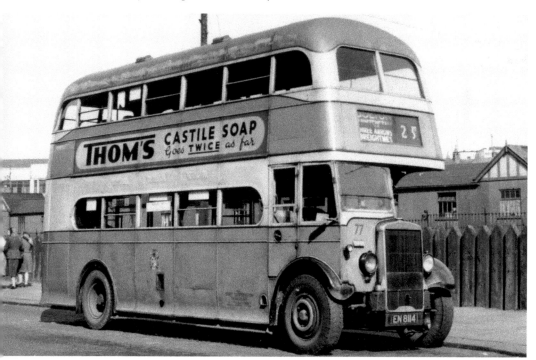

Leyland TD5 Northern Counties 77 EN 8114 was new in July 1939. It would give fourteen years of service to the town.

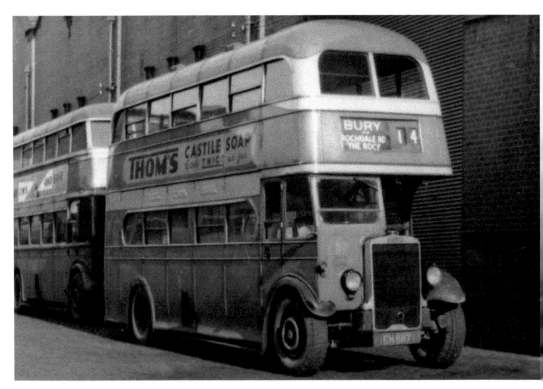

Another TD5 from the same batch of five outside the Rochdale Road depot in 1948.

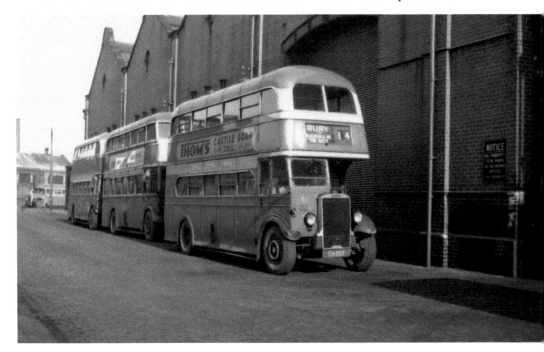

The same bus, on the same day, with one of the new Roe-bodied Leyland single-decks in the background.

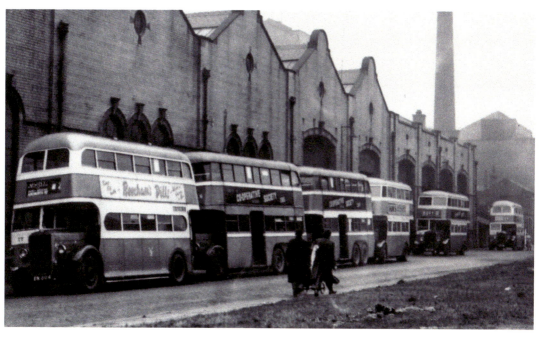

The Rochdale Road depot. Outside the George Street exit in 1946 is a selection of Leyland Titans and Titanics.

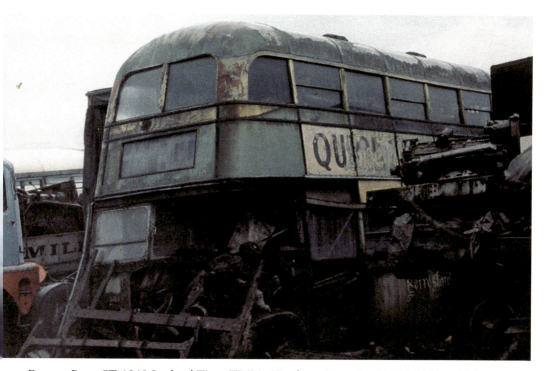

Former Bury CT 1940 Leyland Titan TD7 is Northern Counties 84 EN 8252, withdrawn in 1953 and sold to Berresford Cheddleton, near Leek in Staffordshire. It is seen here in Jim Berresford's yard in 1972.

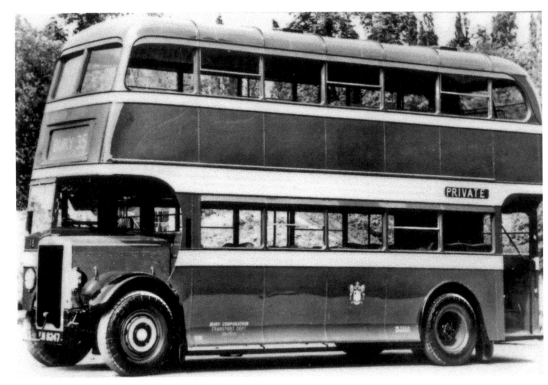

1940 Weymann-bodied Leyland TD7 88 EN 8247 at Addlestone, Surrey, before delivery.

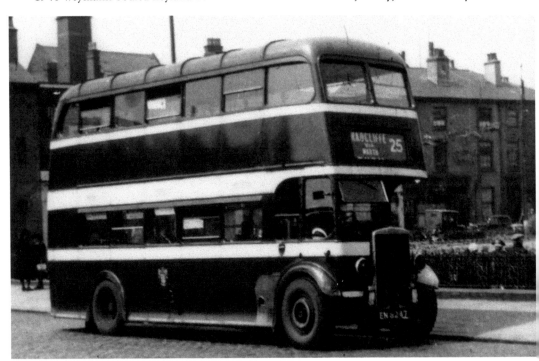

The same bus some four years later.

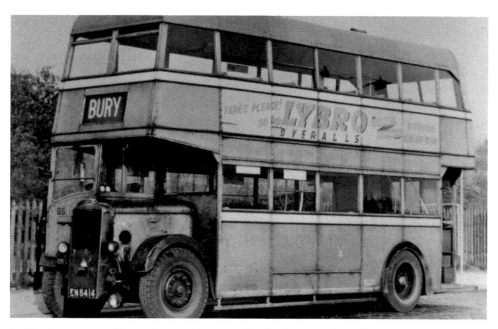

In 1943, Bury was allocated three Massey utility-bodied Daimler CWA6s. In this view from 1946, 95 EN 8414 is shown prior to all three examples getting opening side windows and a full repaint.

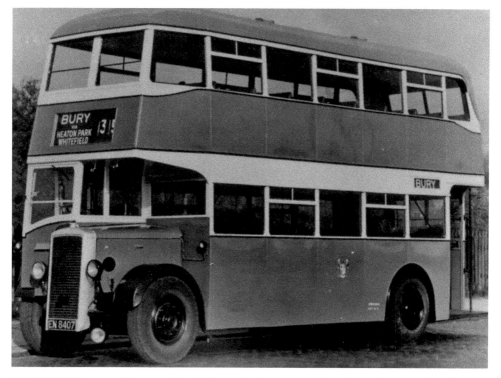

94 EN 8407 is seen with new side windows, dark green mudguards and repainted in the new livery of apple green and primrose.

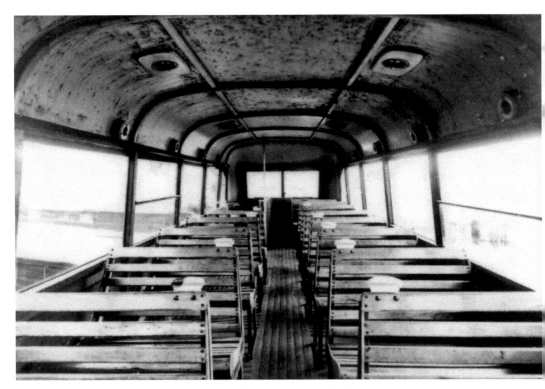

The top deck interior of 95 EN 8414 before being refurbished.

In 1951, all three Daimler utilities were fitted with new bodywork by Chas Roe of Leeds at a total cost of £4,854.

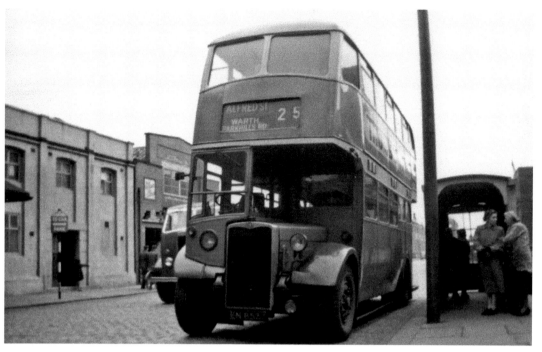

In June 1946, Bury took delivery of five Crossley DD42/3s fitted with Crossley's own 8.6-litre HOE7/1 engine rated at 100 bhp. In 1954, all five were fitted with Leyland engines. 99 EN 8533 is seen in Market Street.

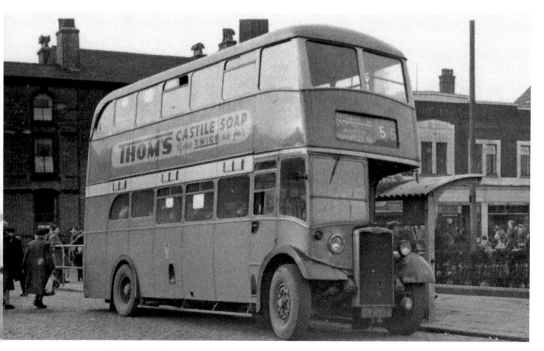

Also in 1954, all the Crossleys had their front mudguards shortened to improve airflow to the front brakes.

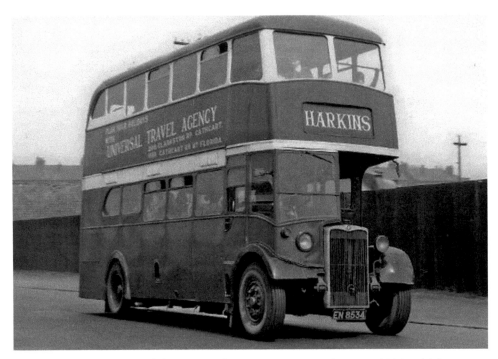

All the Crossleys were withdrawn in July 1958. One example is EN 8534, which went to Harkins in Glasgow.

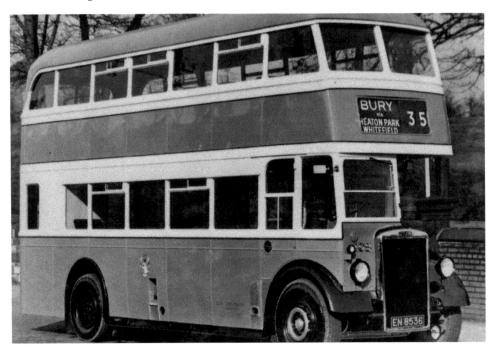

Such was the condition of the fleet in 1945, caused by six years of neglect and staff shortages, that orders were placed for fifty-two new buses – the majority double-deckers. The first one to be delivered came in March 1946 and was this Roe-bodied Leyland PD1, 102 EN 8536.

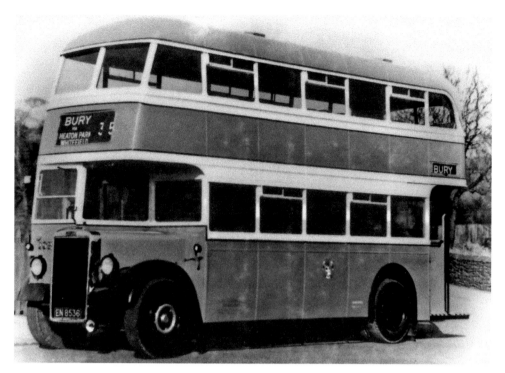

A nearside view of the same bus.

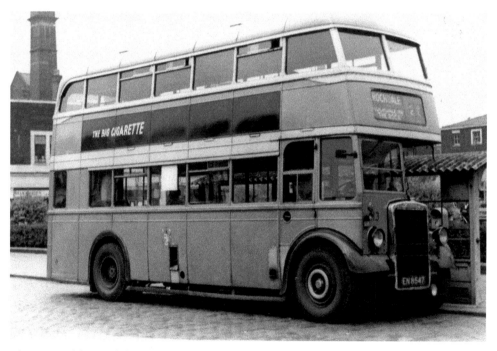

There were fifteen of these Roe-bodied PD1s. Fleet No. 102 was the first of Leyland Motors' new PD1 model to enter service. It was not the first chassis built, however. That honour went to Blackburn Corporation, but that example did not enter service until May 1946.

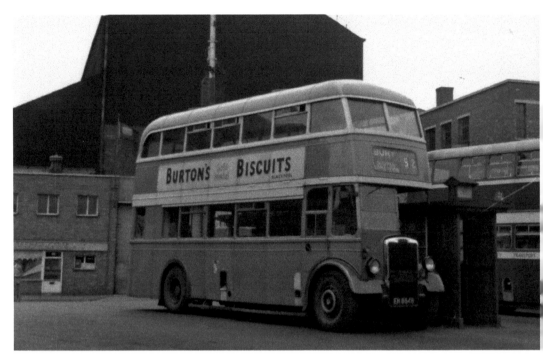

Over the course of thirteen years, between March 1946 and January 1959, Bury Corporation Transport took delivery of no less than 121 new buses. The majority of these were double-deckers, and seven had a rebodied double-deck chassis.

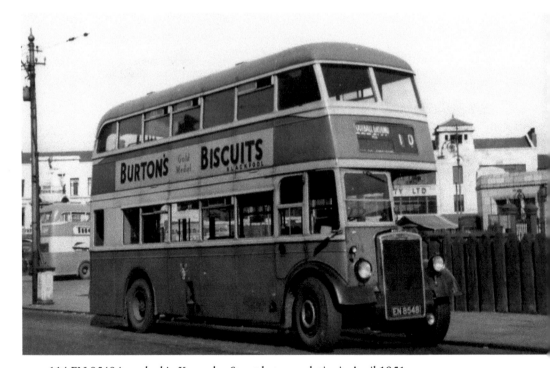

114 EN 8548 is parked in Knowsley Street between duties in April 1951.

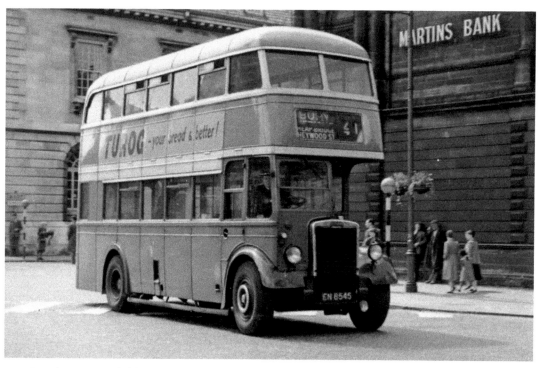

Seen here in Rochdale on the joint 21T service is 111 EN 8545, which was withdrawn from service shortly after this photograph was taken.

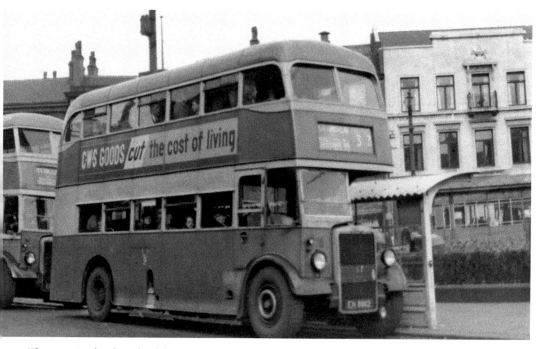

The next Leylands to be delivered were more PD1s, only this time with bodywork by Northern Counties of Wigan. A total of thirteen, the first ones came in December 1946.

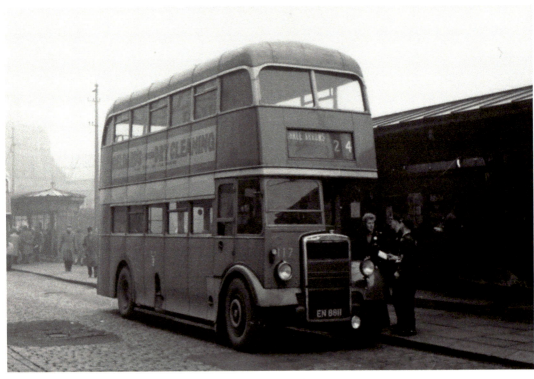

117 EN 8811 about to leave on the 24 service to the Three Arrows.

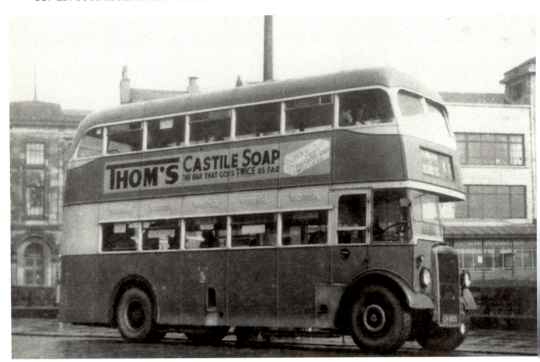

Another NCME-bodied PD1 at Kay Gardens, in the original variation of the new green livery

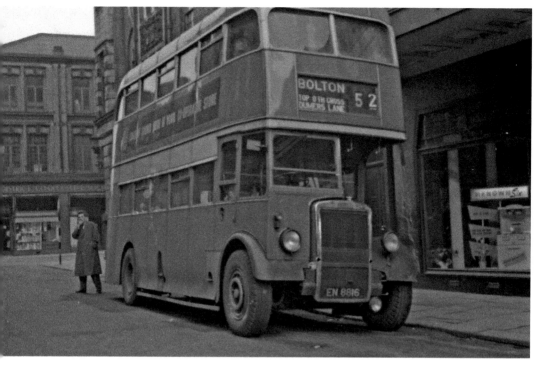

A passenger's curiosity of why anybody would want to photograph a bus. 122 EN 8816 in Broad Street on the 52 service to Bolton via Radcliffe and Little Lever.

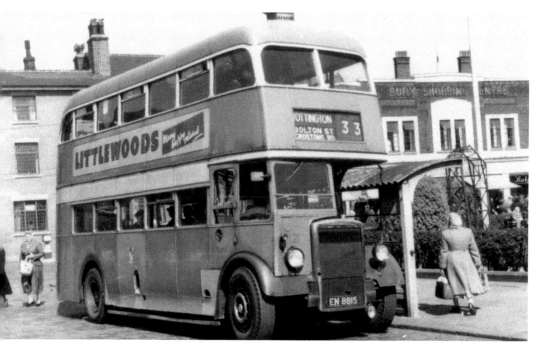

This classic view of Northern Counties Leyland PD1 121 EN 8815 on the 33 service to Tottington.

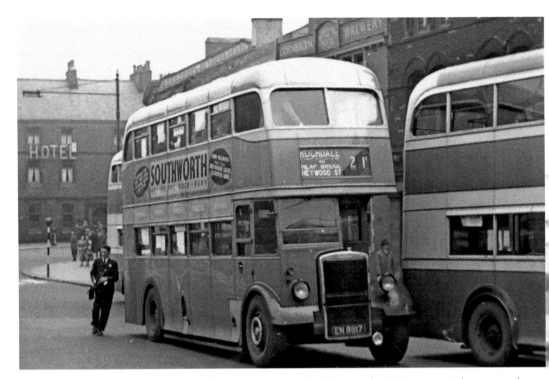

Another classic shot, this time in Rochdale in the early 1950s on the 21T to Bury. It has stopped next to a pre-war Rochdale Daimler COG6.

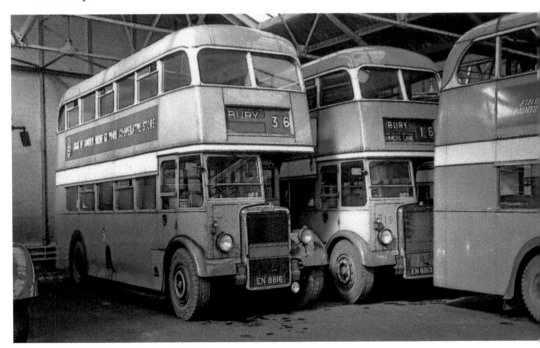

Two Northern Counties PD1s parked in the north garage, which was on Rochdale Road opposite the main depot.

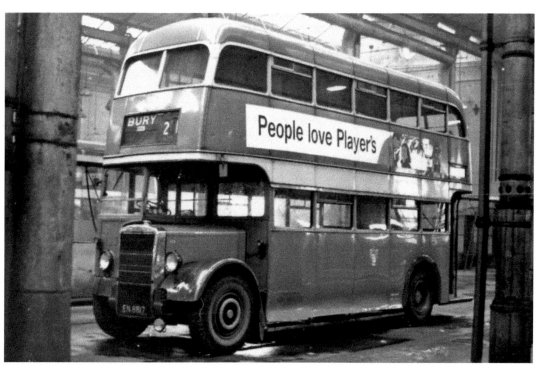

123 EN 8817 stands in the main depot in 1963 shortly before being sold to H. Hoyle in Barnsley for scrap.

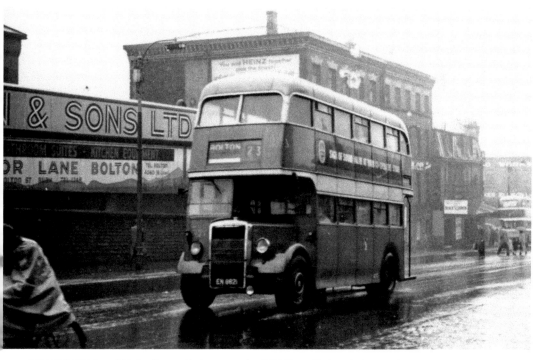

127 EN 8821 on Trinity Street, Bolton, on the 23T Bury–Bolton joint service.

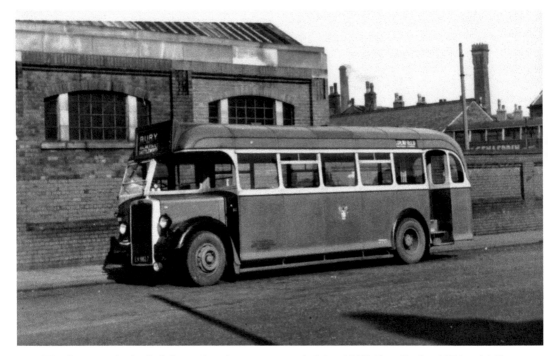

The first new single-deck buses for nine years came in May 1947. Four Leyland PS1s with Roe thirty-five-seat, rear-entrance/exit bodywork. 133 EN 8827 is seen here on Rochdale Road when new.

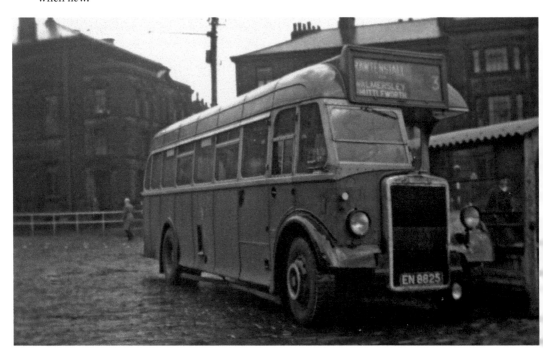

The new single-deckers were used at first on the 3 service to Rawtenstall, via Walmersley and Edenfield.

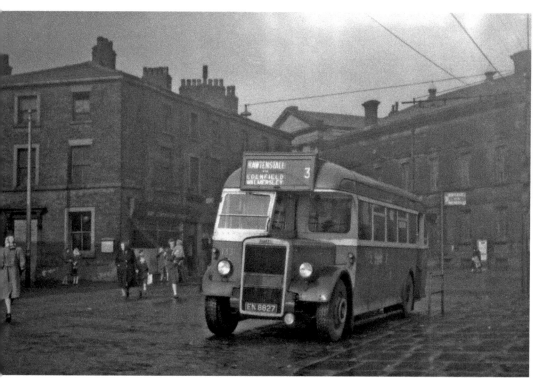

Waiting on stand at Bury ready for the 9-mile journey to Rawtenstall is 133 EN 8827.

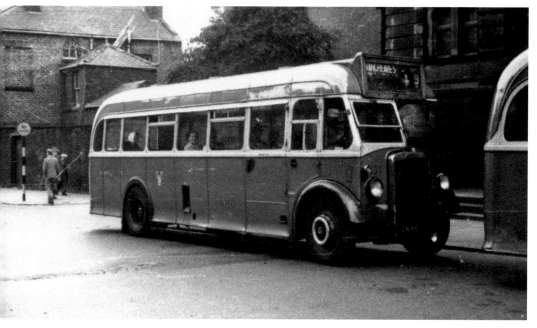

In 1954, all four of the Roe-bodied single-decks were converted from rear to front entrance by Northern Counties to make them suitable for one-man-operation. They were also used at time on the 49 service to Nangreaves.

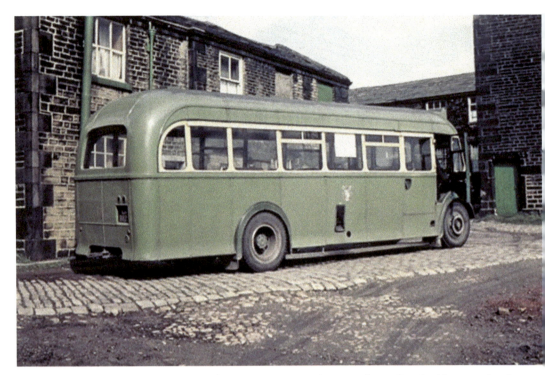

At the Nangreaves terminus stands 132 EN 8826. It has now been fitted with a tow hook, enabling it to deputise for the breakdown vehicle should the need arise.

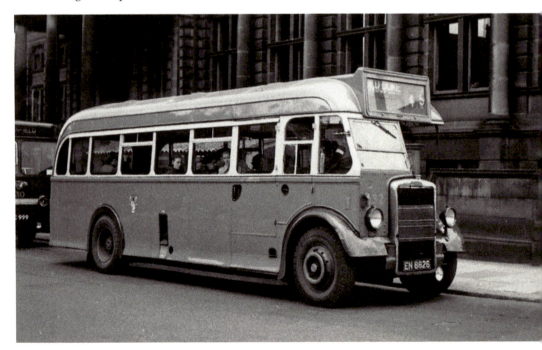

132 EN 8826 is seen on Moss Street on the 45 to the Old Duke public house on Brandleholme Road.

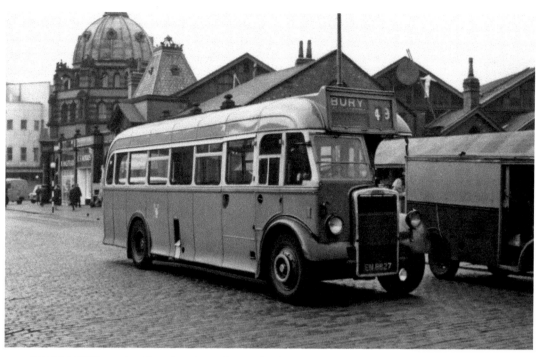

133 EN 8827 passing Bury Market. The market has now moved to behind the cinema, at the left-hand side of the photograph, and the bus/metrolink interchange now occupies the area adjacent to the bus.

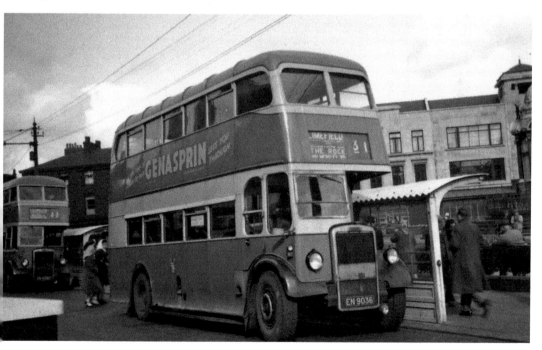

The last batch of new Leyland PD1s were fifteen of the revised PD1A chassis with Weymann bodywork, which would become the town's number one choice for new bodywork until 1964.

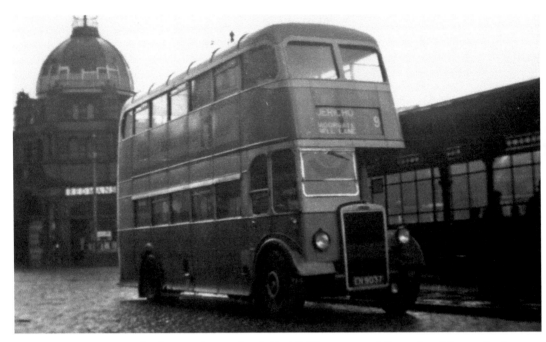

137 EN 9037 stands close to the market hall. All fifteen were delivered and in service by August 1947.

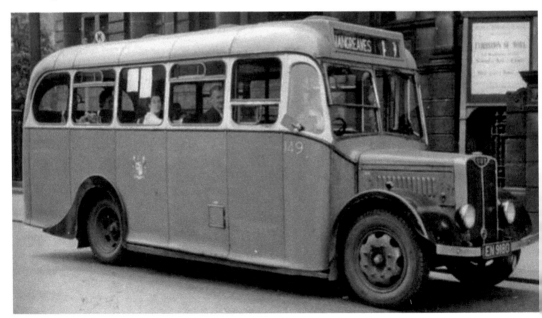

The residents of Nangreaves, a small cluster of houses high above Walmersley, had been asking the town council to provide a suitable bus service as far back as 1936. Eventually, in the summer of 1948, a service was started using two Barnard-bodied, twenty-seat Guy Wolfs, which were supposedly a cancelled order by South Sheid Corporation and obtained at a reduced price. They only lasted in service for six years, being replaced by standard Leyland single-decks. 149 EN 9180 is about to leave for Nangreaves.

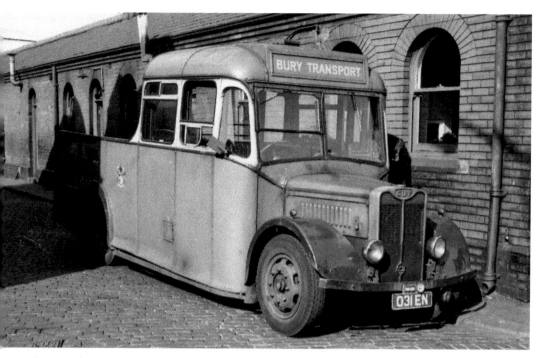

The same bus had part of the bodywork removed and was used as a bus shelter maintenance vehicle until 1961, when it was sold to a local garage as a breakdown truck and fitted with a rear crane.

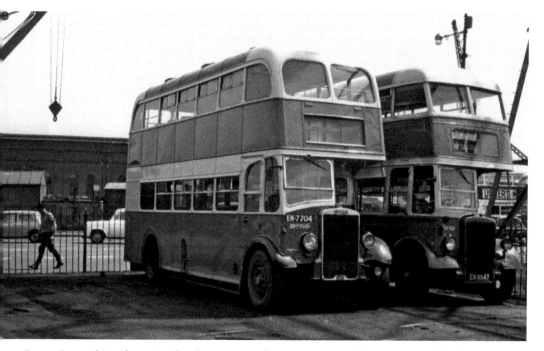

Paton Bros of Renfrew, Scotland, was a good customer for old Bury buses. EN 7704 and EN 8547 went to Scotland in October 1958.

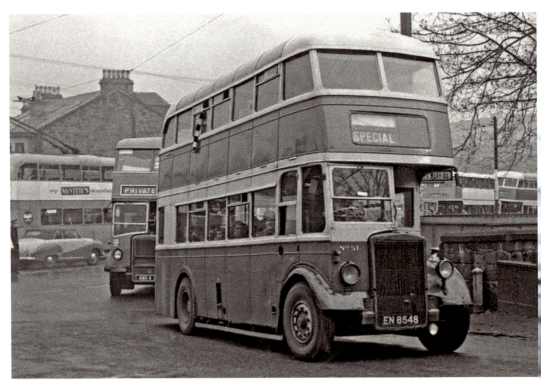

51 EN 8548 in the Paton fleet is a Roe-bodied PD1, seen here on a football special duty.

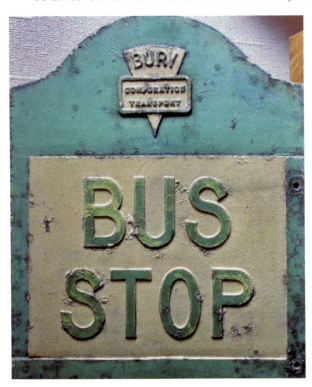

This is a typical bus stop flag that was in use up until the end of the 1960s.

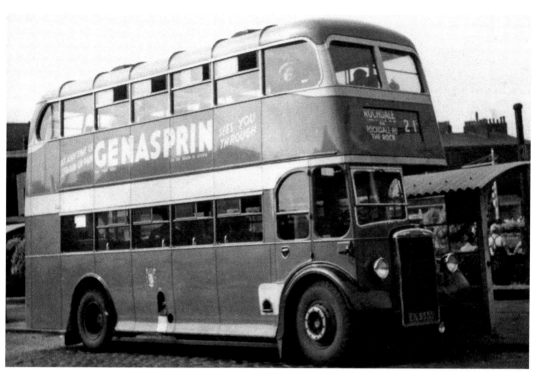

Bury Corporation only ever placed an order for a batch of more than twenty new buses of the same specification twice in its entire existence. The first time was in 1948 and the other was in 1957. They ordered twenty-five, 8-foot-wide Leyland PD2/4s with Weymann fifty-six-seat bodywork for delivery between April 1949 and January 1950. 155 EN 9555 is seen at Kay Gardens new and in service.

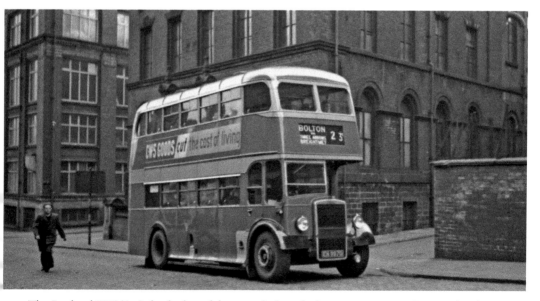

The Leyland PD2/4 air-braked model was only bought by two operators: Bury and Bolton. 170 EN 9970 is seen on Bridgeman Place in Bolton.

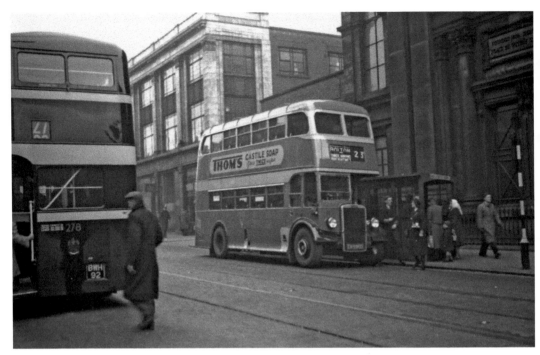

160 EN 9960 is seen here on Great Moor Street, Bolton, about to load on its return trip to Bury, opposite one of Bolton Corporation's sixty-seven Craven- and Crossley-bodied DD42/3 278 BWH 92, which was new in 1946.

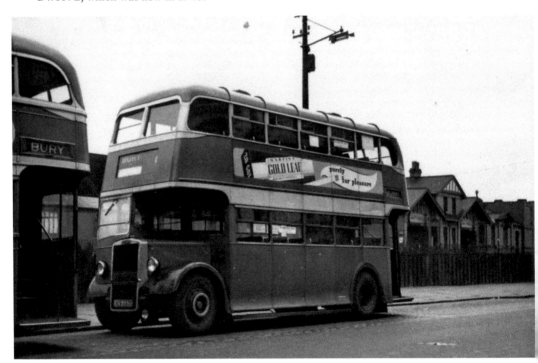

PD2 152 EN 9952 is parked in Knowsley Street on 12 April 1952.

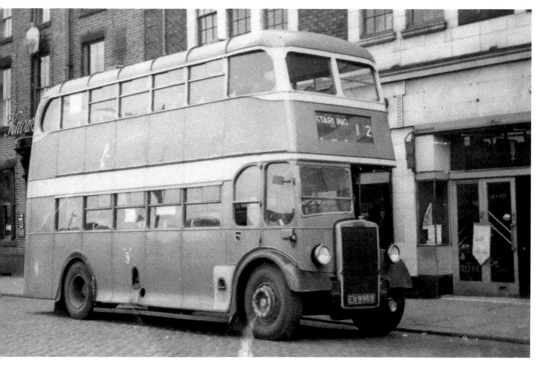

169 EN 9969 on route 12 to Starling.

The area behind 174 EN 9974 has changed very little since this photograph was taken.

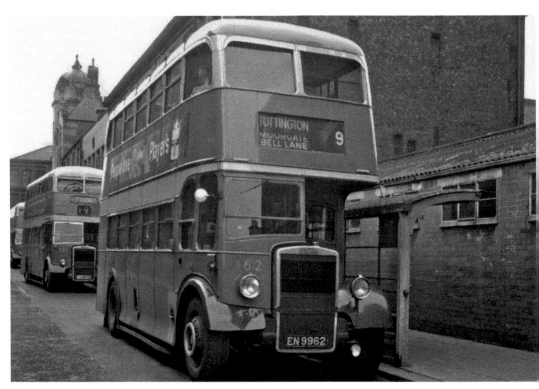

Broad Street was another popular stopping place in the town centre. 162 EN 9962 is seen on the cross-town service between Jericho and Tottington. Bringing up the rear are two Leyland PD3s.

A driver and conductor are posing for the camera outside the depot alongside 168 EN 9968.

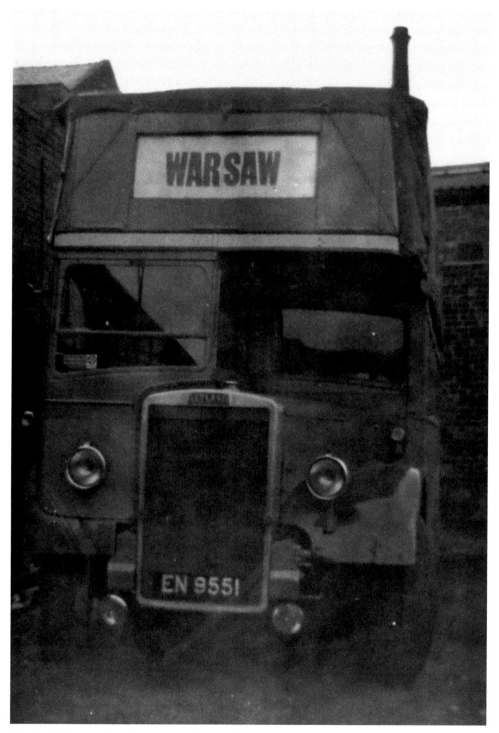

151 EN 9551 was bought by Bury Chess Club in May 1967 for a trip to Poland. Unable to pass under low bridges in Germany, the top deck had to be removed. When it returned to Bury it was sold for scrap.

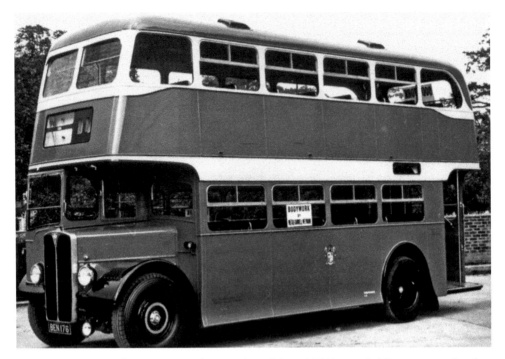

Bury Corporation made a surprise purchase in 1952 of these AEC Regent 3s. The story goes that they bought three AEC chassis to have them bodied as fire engines. In the end only one ended up with the town's fire brigade – AEC-Merryweather BEN 114. The other two chassis were eventually bodied by Weymann. The first one, 176 BEN 176, is photographed at Addlestone in September 1952.

The same bus in Cannon Street, Manchester, not long after entering service.

The second AEC Regent, 177 BEN 177, is seen in Rawtenstall town centre in the summer of 1953.

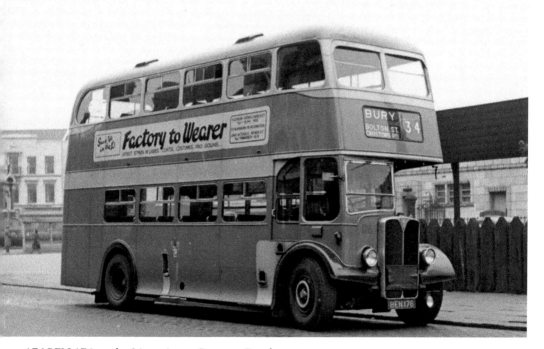

176 BEN 176 on the 34 service to Crostons Road.

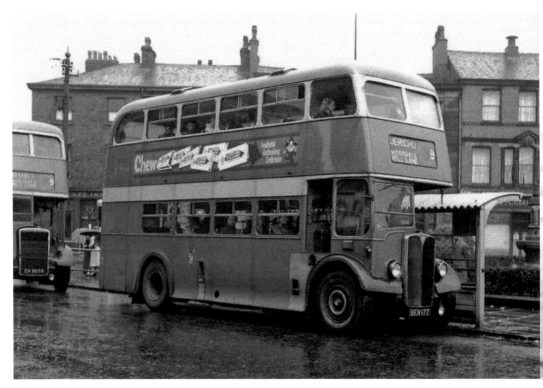

177 BEN 177 at Kay Gardens in 1958.

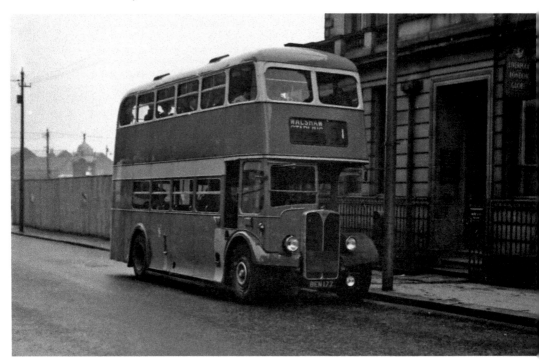

177 BEN 177 on Market Street.

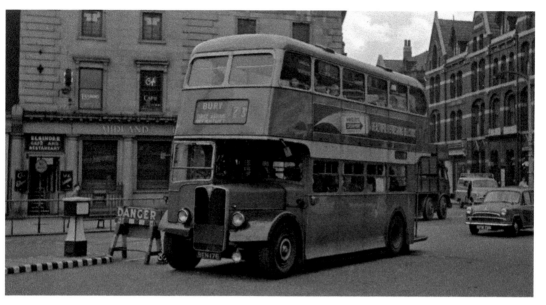

176 BEN 176 at the Market Place, adjacent to the Transport Department offices. 176 is now preserved and stored at the Museum of Transport, Boyle Street, Manchester.

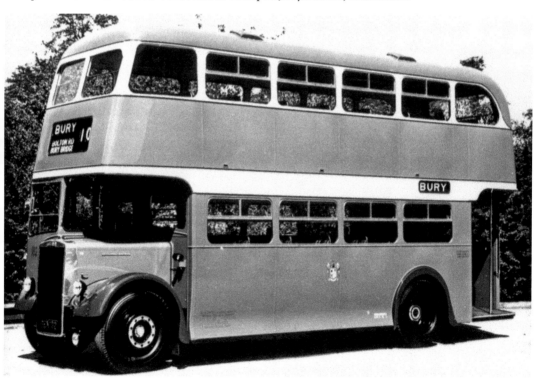

The next new buses came in 1953: nine Weymann-bodied Leyland's – the town's first choice. 182 BEN 182 is at the Weymann factory in Surrey. In the period between March 1946 and June 1953, Bury had taken delivery of ninety new buses, which left only seven pre-war buses in the fleet.

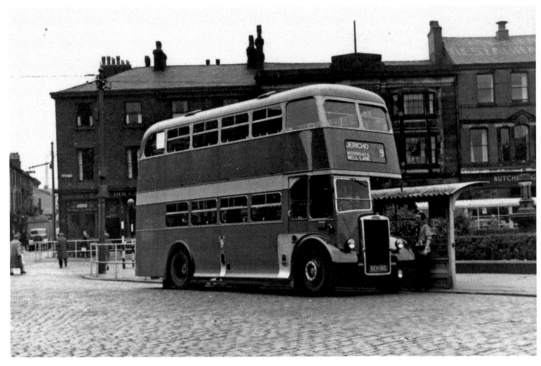

180 BEN 180, although designated as a PD2/3, seemed to be a transitional type with several characteristics of the PD2/12.

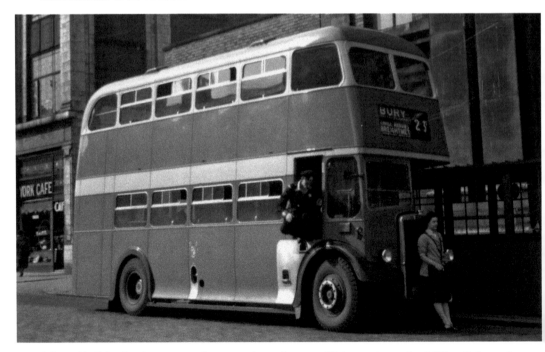

These 1953 Leylands were used on a variety of routes. This one is on the 23T to Bolton via Breightmet.

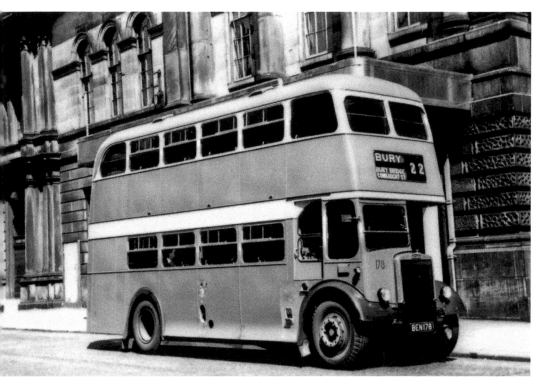

178 BEN 178 outside Bury Athenaeum, which was demolished in 1958.

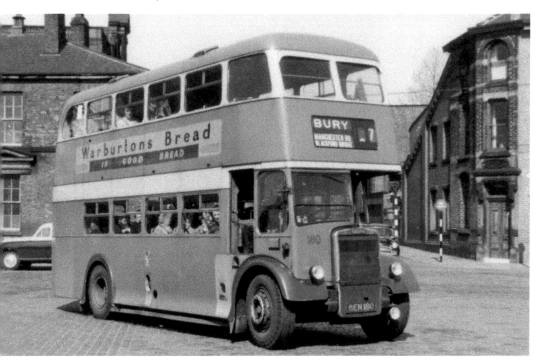

180 BEN 180 is entering Kay Gardens on the 7 service.

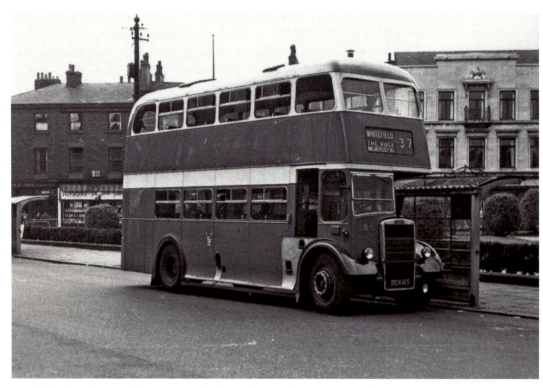

The classic lines of the Weymann bodywork are still in pristine condition in 1958.

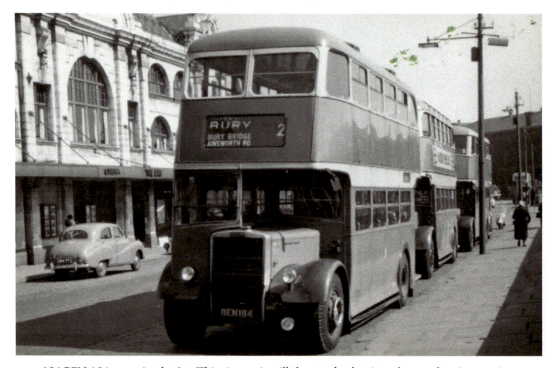

184 BEN 184 opposite the Art. This cinema is still there today but is no longer showing movies.

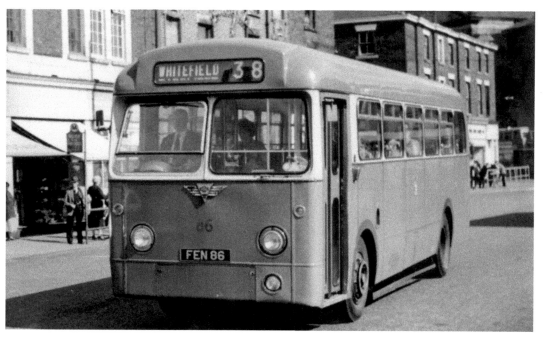

With all those Leylands, both double-decks and single-decks, you would have expected that the Leyland Tiger Cub would have been the first choice for new single-deckers. But six AEC Reliances with forty-three seat-Weymann Hermes bodywork were ordered. All six were delivered in April 1957 at a cost of £4,313 per bus. This image shows 86 FEN 86.

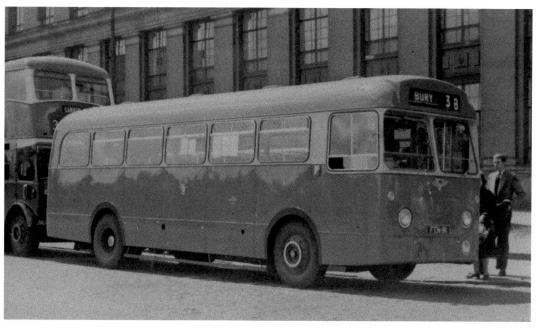

Seen during its first week in service, 81 FEN 81 is loading outside the technical college on Market Street on the 38 service to Unsworth and Whitefield. Behind is Manchester Corporation 1950 Leyland PD2/3 on the 35 service to Manchester city centre.

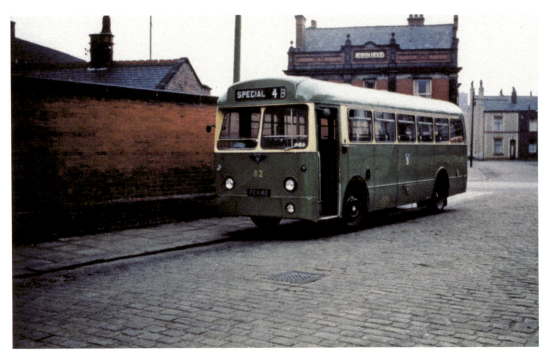

82 FEN 82 is parked at the side of the Rochdale Road depot. It was withdrawn in 1969.

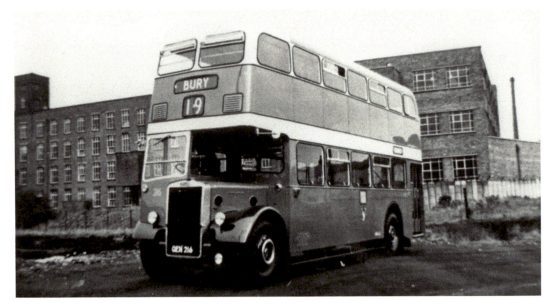

In 1956, Richard Le Fevre, who had been general manager at Bury since 1944, left to take up a similar position at Halifax. His successor was Frank Thorp, who had previously been chief engineer at Nottingham City Transport. He was a manager who certainly had some new and radical ideas. In an interview shortly after his appointment, he said that the town should be looking at bigger buses with more seats and brighter interiors. In 1956, the maximum length for a two-axle double-deck bus was increased from 27 feet to 30 feet. Enter the 30-foot-long Leyland PD3/6, 216 GEN 216.

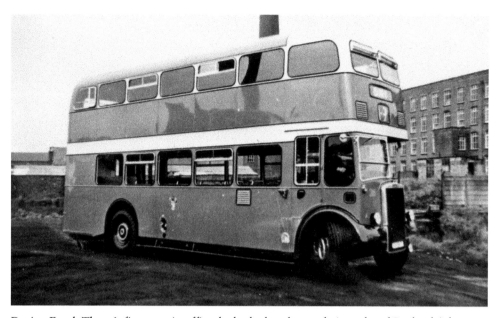

During Frank Thorp's first year in office, he looked at the newly introduced Leyland Atlantean. In March 1957, he borrowed a PMT Metro Cammell-bodied PD3 for a week. He must have been impressed with it because three months later he placed an order for twenty-five Weymann-bodied examples to be delivered in two batches – nineteen in 1958 and six the following year. The total cost of each bus was £5,760 17s and 8d. If they had been supplied without a rear platform folding door the price would have been reduced by £216 per bus.

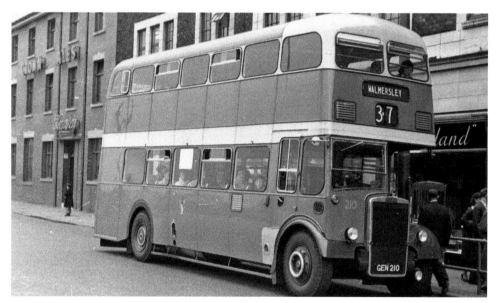

These were certainly impressive buses. They came in the standard colours of green and primrose with dark green wheels and front mudguards, but a new addition was a primrose-painted front dome. It is alleged that it was done to alert garage staff it was 3 feet longer than the rest of the double-deck fleet. 210 GEN 210, the first of the twenty-five to be delivered in March 1958, was new in service on the 37 cross-town service of Walmersley to Whitefield.

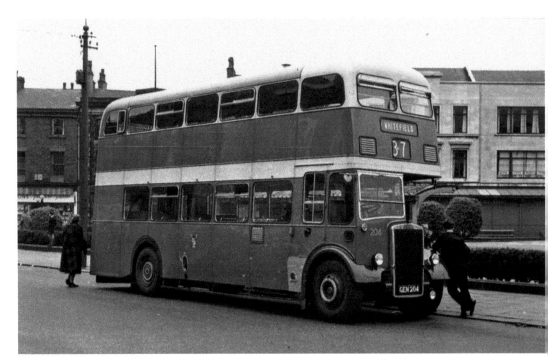

Other features included a platform door. Because they seated seventy-three, which was seventeen more than the PD2s, the conductor would spend more time collecting fares and less time supervising the rear platform. 204 GEN 204 is seen at Kay Gardens.

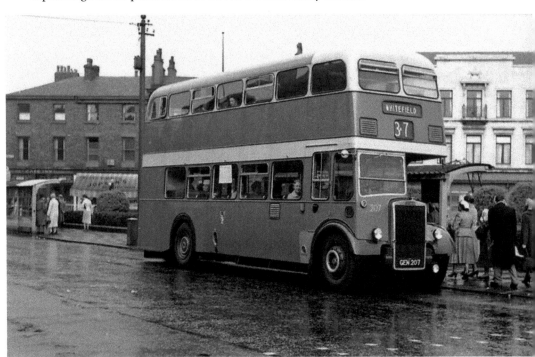

207 GEN 207 on a different day, but the same route.

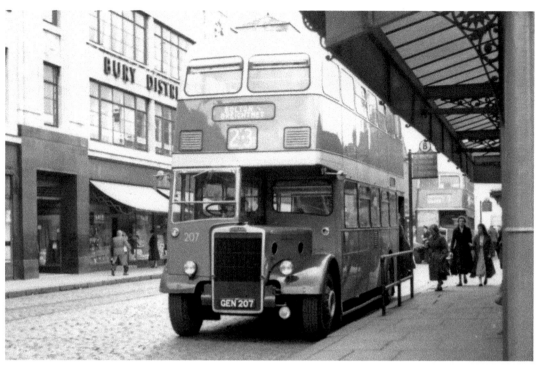

They also spent time on the joint service 23T with Bolton Corporation. 207 GEN 207 is waiting for the driver to arrive.

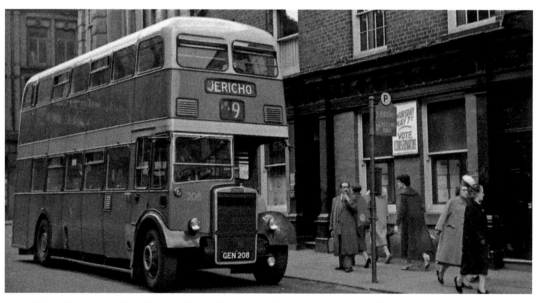

Other features included a new front destination layout with no 'via blind' or front upper-deck opening hopper vents. Frank Thorp brought both of these features with him from Nottingham. An unusual feature was the fitting of rear wheel discs, which did not last in place very long due to the excessive heat generated to the rear brakes. 208 GEN 208 is seen here in Broad Street on another cross-town service.

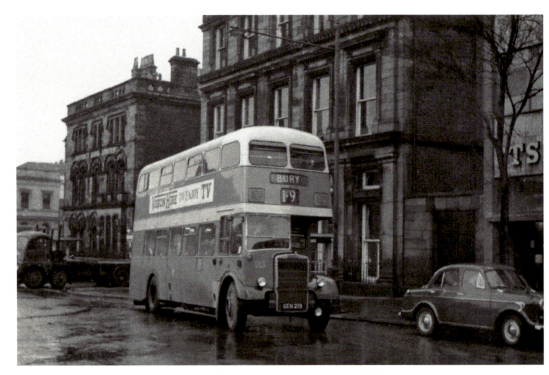

213 GEN 213, minus its rear wheel discs, is about to leave Rochdale on the 19 service to Bury via Jericho.

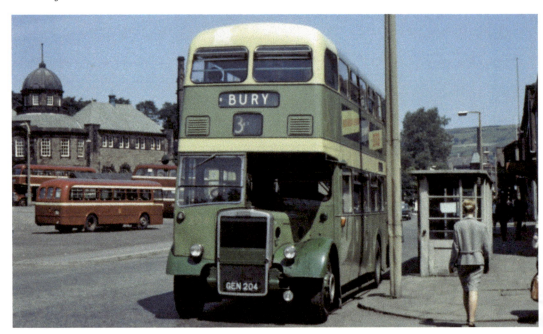

They also sported a much brighter decor. Gone was the dark brown seating; it was replaced with a far brighter green colour, which also featured on the hand poles. 204 GEN 204 is photographed in Rawtenstall with three Rawtenstall Corporation Leylands in the background.

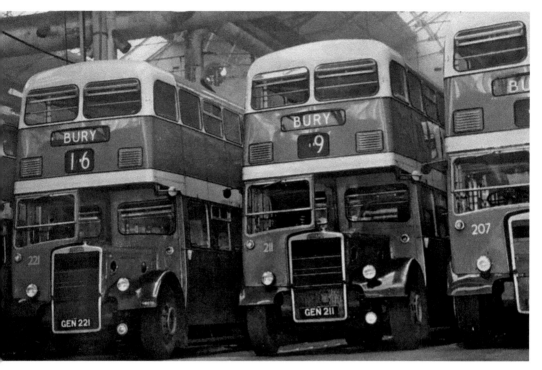

Three Weyman-bodied Leyland PD3/6s, 221, 211 and 207, are parked up in the depot, sometime in 1960.

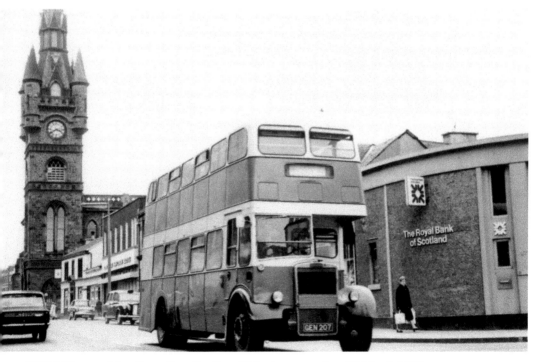

GEN 207 was sold to Paton Bros Renfrew. This view was taken 29 March 1973.

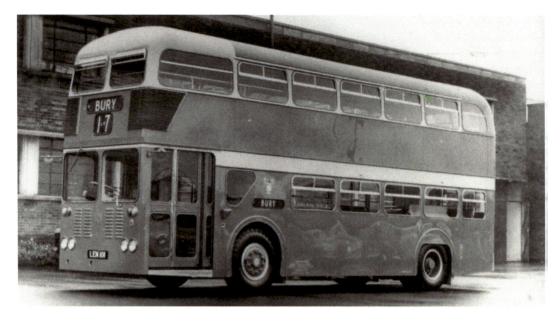

At the 1960 Commercial Motor Show at Earl's Court in London a most unusual bus was present on the Guy Motors stand in the colours of Bury Corporation Transport. It was a front-engine, front-entrance, 30-foot-long double-deck bus named *Wulfrunian*. Bury had never bought any Guy double-deck buses before, but they were about to become the first municipal bus company of this evolutional double-decker. Standing outside the Charles Roe factory in Leeds, en route to London and Earl's Court, is 101 LEN 101.

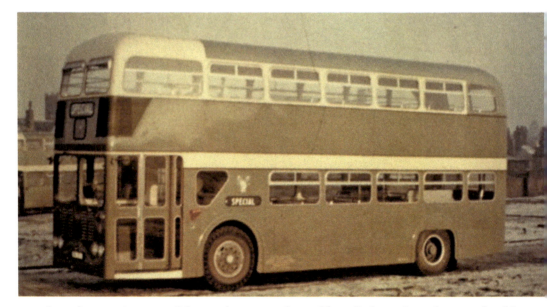

Over the past sixty years I for one have never been able to find out the real reason for this purchase. Frank Thorp must have given the transport committee a very good presentation for them to sanction the purchase of this £7,000 unproven mistake. Whatever the reasons, in less than three years it was gone. It is parked here on 'The Moses' shortly after entering service, still with its rear wheel 'spats' fitted.

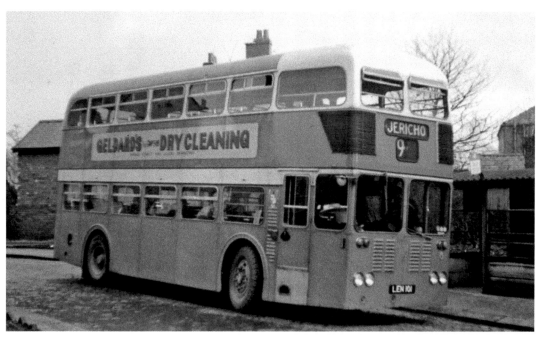

It was to spend a lot of time off the road with various mechanical issues. Steering was on the heavy side and the driver's space in the cab was cramped. The front brakes had a tendency to overheat and there was excessive front tyre wear, caused by the steering geometry and the weight of the front-mounted Gardener engine. It is seen here at the Tottington terminus in 1962.

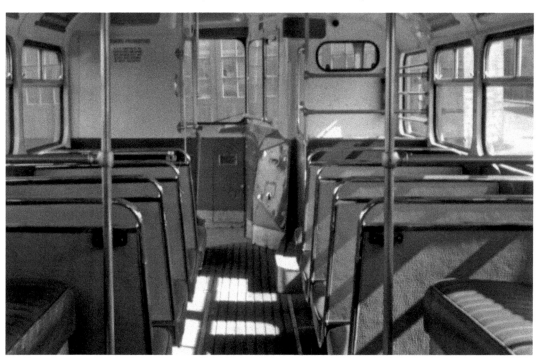

The Wulfrunian lower-deck interior, looking forward.

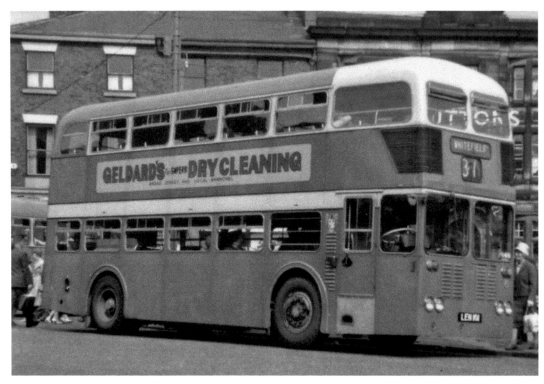

One of the few times in service on the 37 to Whitefield.

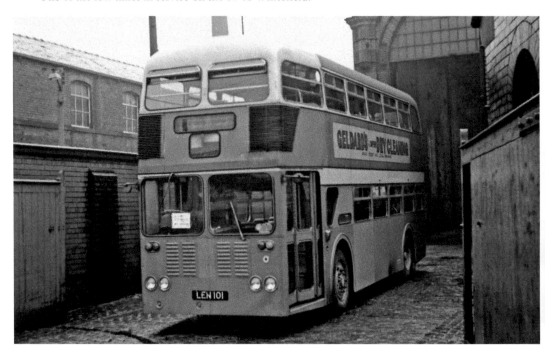

The day it was sold in November 1963 for the sum of £2,500. It is seen here waiting to be collected by its new owner, Howell & Withers of Pontilanfraith, Monmouthshire, South Wales.

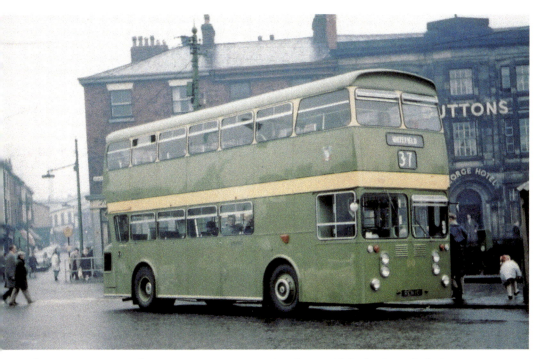

The town's next new buses were more conventional, even if the bodywork design was not. Fifteen MCW-bodied Leyland Atlantean PDR1/1s arrived from April to June 1963. 110 REN 110 is seen on its first day in service – 8 April 1963.

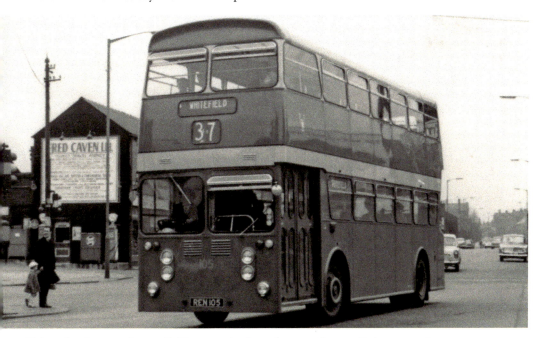

This style of Metro-Cammell-Weymann bodywork was only supplied to two other operators – Bolton and Liverpool. Note the lower front nearside opening vent. This was later removed as it obstructed the driver's nearside mirror.

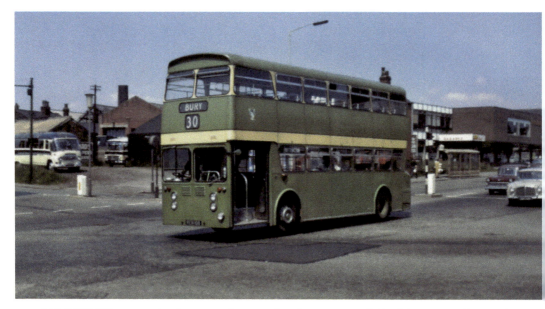

108 REN 108 – note the front opening vent has been removed. Fred Caven coaches at the bottom of Walmersley Road. Bus 108 is in motion with the entrance door left open – that would not be allowed to happen today.

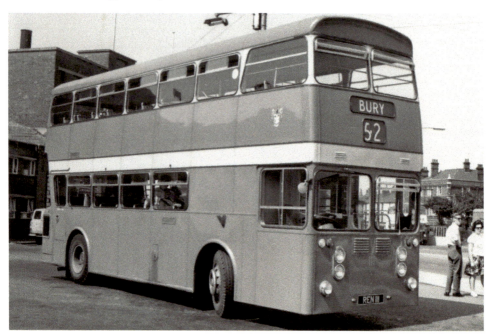

In January 1963, Frank Thorp resigned his position with Bury Corporation Transport and moved to Newport in South Wales. Three months earlier he had placed orders for thirty-two new buses. Fifteen Leyland Atlanteans, fifteen Alexander-bodied Daimler Fleetlines and two AEC Reliances, also with bodywork by Alexander. He left Bury before any of the new buses had been delivered. 111 REN 111 stands in Thynne Street, Bolton. Four headlights and two fog lamps seems a bit excessive.

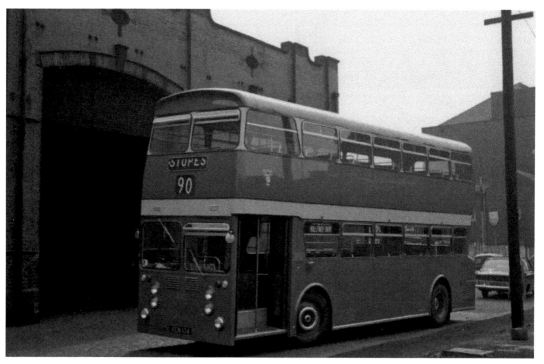

104 REN 104 parked in George Street on 20 April 1963.

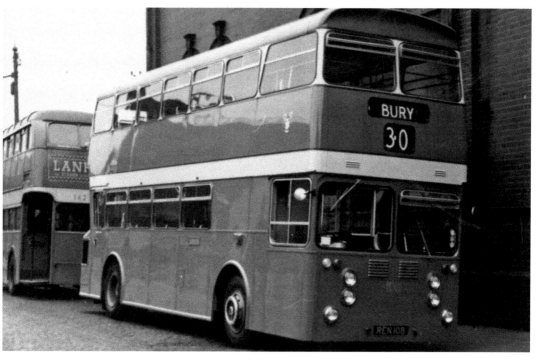

108 REN 108 again in George Street with a rear view of a Weymann-bodied Leyland PD1A, 142 EN 9042.

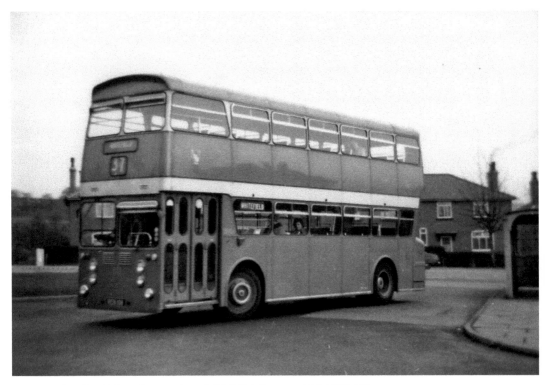

Leaving the Walmersley terminus is MCW Atlantean 108 REN 108.

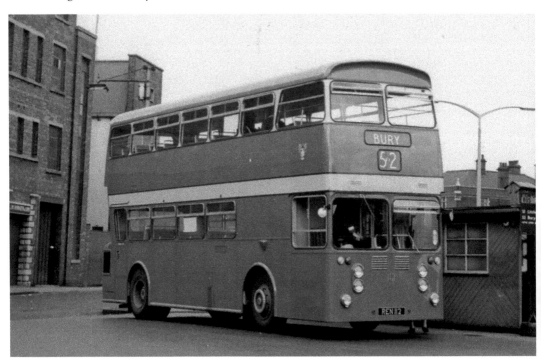

Both Bury and Bolton had MCW-bodied Leyland Atlanteans on the joint 52 service.

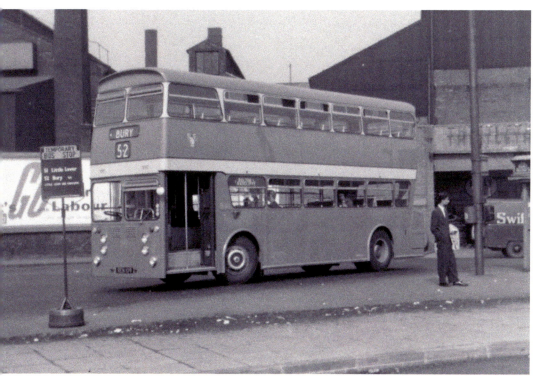

Thynne Street, Bolton, and the new 109 REN109.

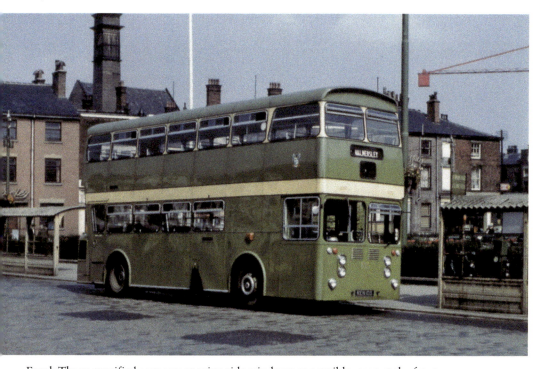

Frank Thorp specified as many opening side windows as possible, even at the front.

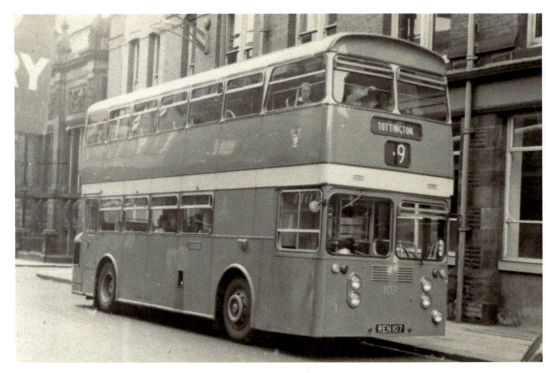

107 REN 107 is on the 9 to Tottington, seen on Broad Street, Bury, on 6 August 1964.

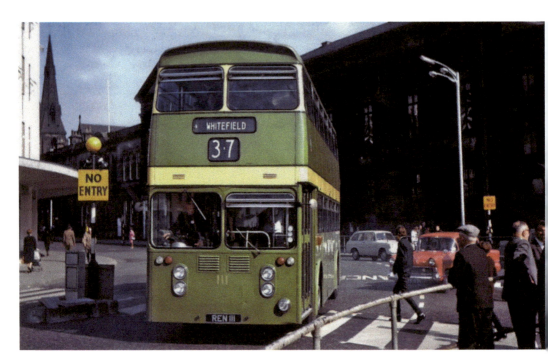

111 REN 111. Not long after this view was taken the whole area would become a one-way system.

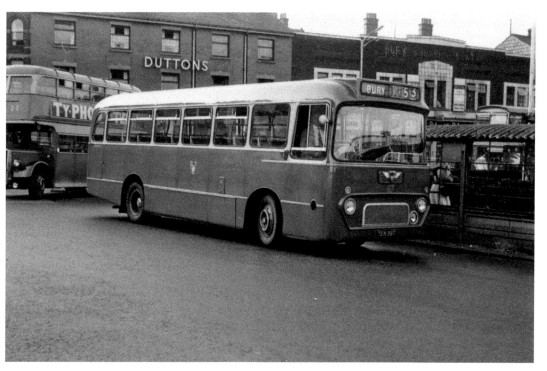

The next two new AEC Reliance single-deckers of 1964 would be fitted with Alexander Y-type bodywork. 87 TEN 887.

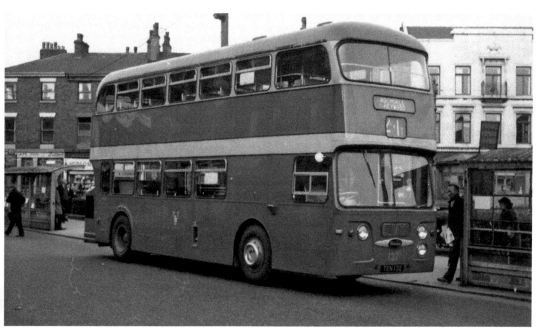

After buying large numbers of Leylands, the majority with Weymann bodywork, a change of direction came in 1964 with fifteen Gardner-engined Daimler Fleetlines with stylish Alexander A-type bodywork. 122 TEN 122 is seen on its first day in service, 25 March 1964.

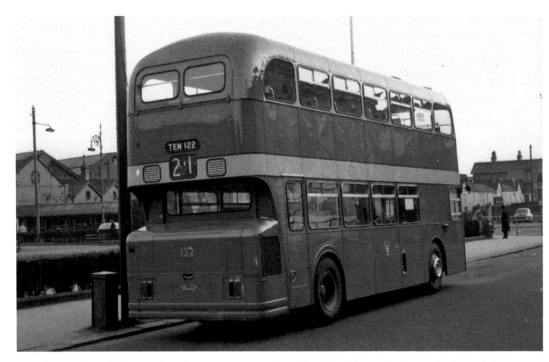

A rear view of the same bus showing the curved profile of the Alexander A-type bodywork. Bury was the only Lancashire municipal operator of the Alexander-bodied Fleetline or Atlantean. All new buses now featured interior fluorescent lighting.

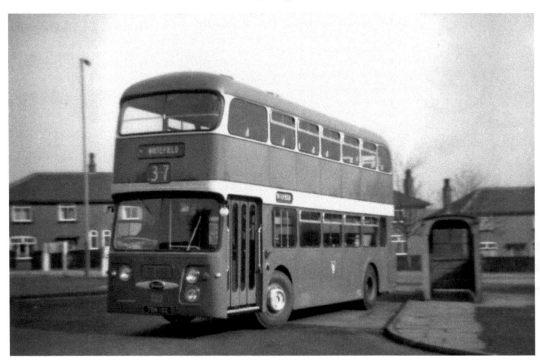

The Walmersley terminus is the location for new Daimler Fleetline 122 TEN 122.

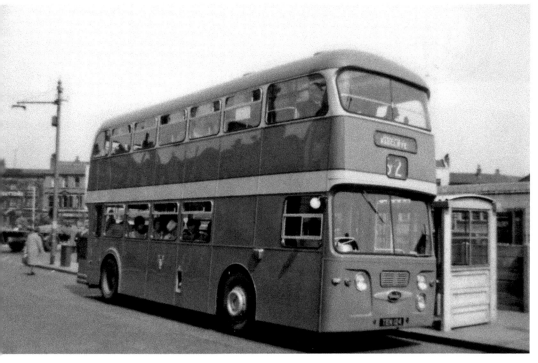

124 TEN 124 about to depart for Bolton on the 52. It is operated jointly with Bolton Corporation.

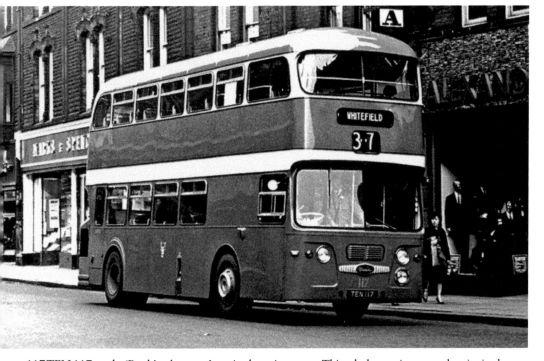

117 TEN 117 on the 'Rock' – the town's main shopping street. This whole area is now pedestrianised.

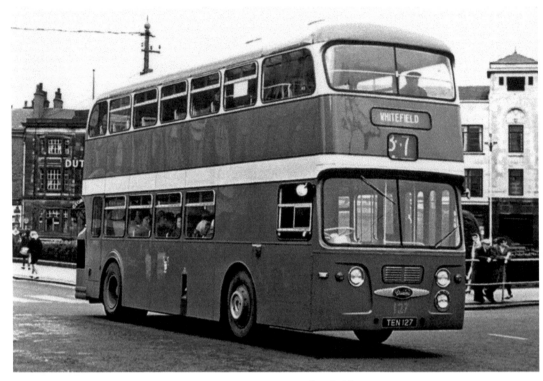

127 TEN 127 is about to leave Bury town centre for Whitefield.

123 TEN 123 on Haymarket Street. This street is now one way – only now in the opposite direction.

A fine colour view of Fleetline 121 TEN 121.

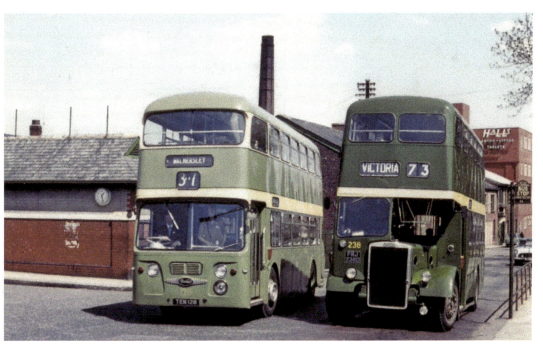

128 TEN 128 at Whitefield bus station in the company of Salford City Transport MCW Orion-bodied Leyland PD2/40 238 FRJ 238D.

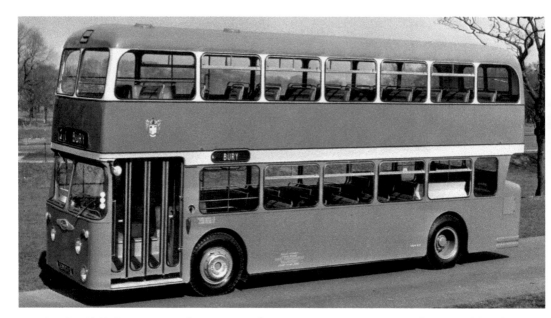

In May 1963, Bury appointed a new general manager, Henry Norman Kay, for a monthly salary of £188. He had previously been deputy general manager at West Bromwich Corporation. Norman was born locally in Ramsbottom in 1923. His first new purchases were six more Daimler Fleetlines, this time fitted with bodywork by East Lancashire Coachbuilders of Blackburn. Delivered in April 1965, they featured a different single aperture destination display. 134 AEN 834C is photographed here in Blackburn before delivery.

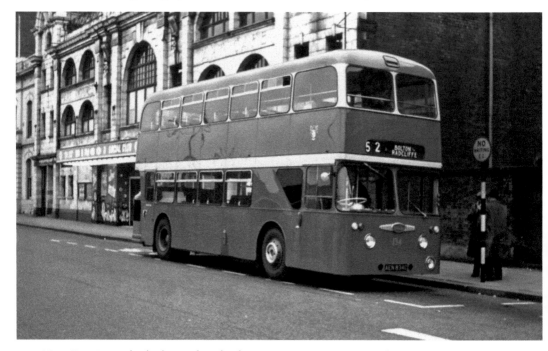

New East Lancs-bodied Daimler Fleetline 134 AEN 834C on Market Street outside the Art cinema, 17 April 1965.

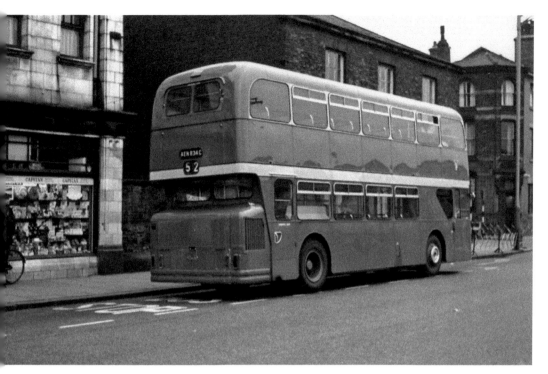

The rear profile of Fleetline 134. This style of East Lancs bodywork was only supplied to three other operators – Coventry, Sheffield and Warrington.

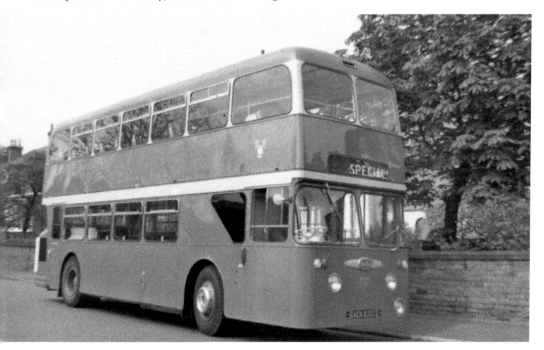

132 AEN 832C, the first of the 1965 East Lancs-bodied Daimler Fleetlines. This image may have been taken on the delivery run from Blackburn.

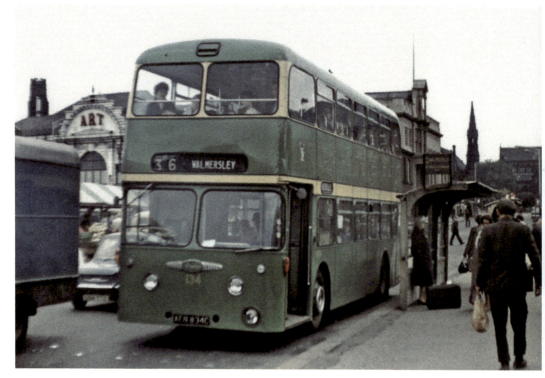

134 AEN 834C at Kay Gardens, opposite the market hall.

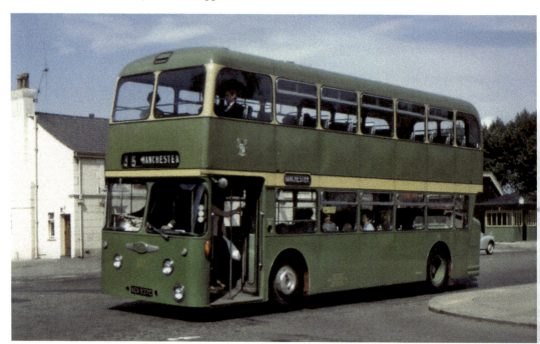

137 AEN 837C en route to Manchester on the 35, seen opposite the Swan and Cemetery public house on Manchester Road.

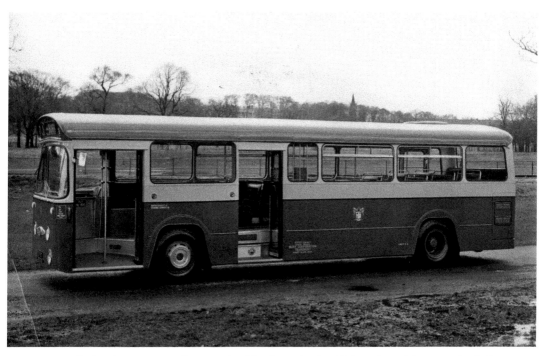

Bury took the decision to order Daimler Fleetlines for its 1967 order of three single-deckers fitted with two-door East Lancs bodywork. 89 FEN 89E is photographed in Blackburn before delivery to the customer.

91 FEN 91E was the last of the three East Lancs-bodied Daimler Fleetline SRG6LXs – 30-foot-long single-deckers. It is seen here at the entrance to the Rochdale Road entrance on Wednesday 22 March 1967, having just arrived from Glasgow via Blackburn. Out of a total of over 11,000 Fleetline chassis built, only 358 were sold as single-deckers.

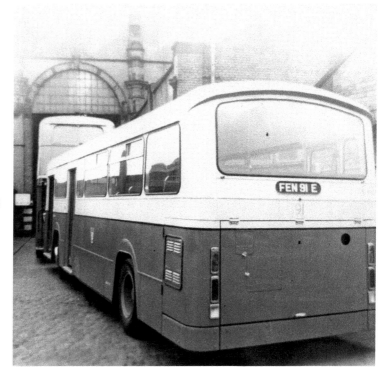

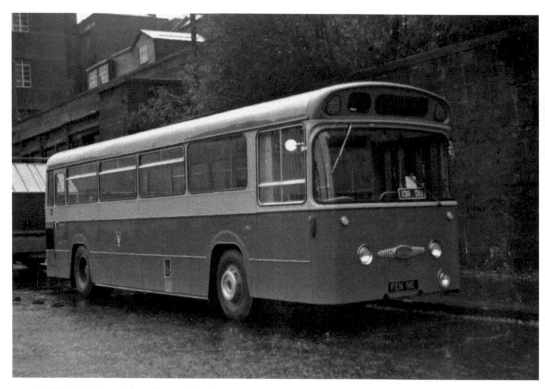

91 FEN 91E outside Kelvin Hall, Glasgow, in March 1967.

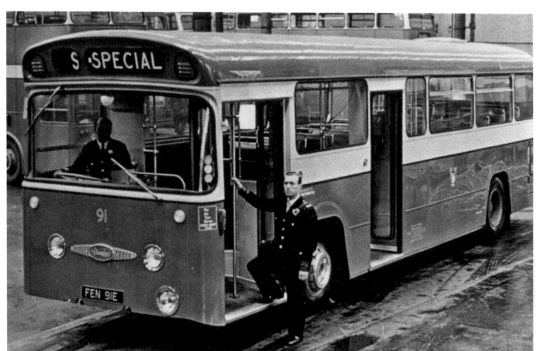

The same bus on its return from Glasgow in March 1967.

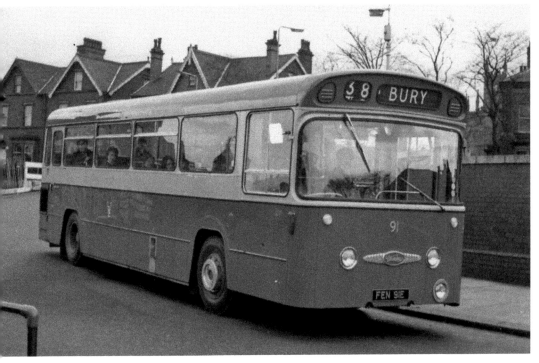

These buses were used primarily on the 38 Whitefield–Unsworth service. 91 FEN 91E is seen once more.

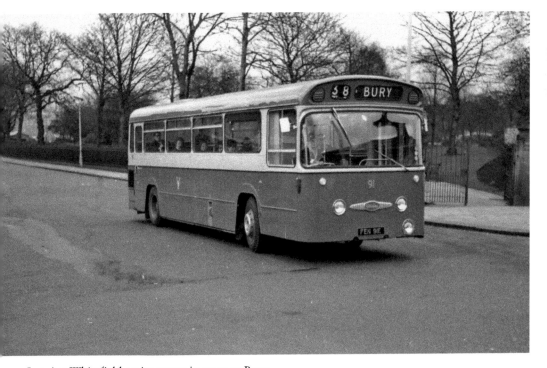

Leaving Whitefield on its return journey to Bury.

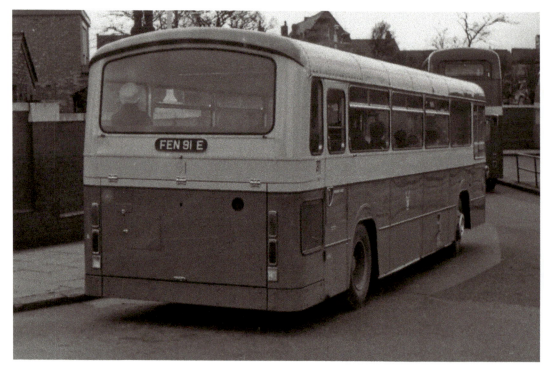

A rear view of fleet No. 91, showing its totally enclosed rear engine. Some other body manufactures of the SD Daimler Fleetline kept the standard rear engine bustle.

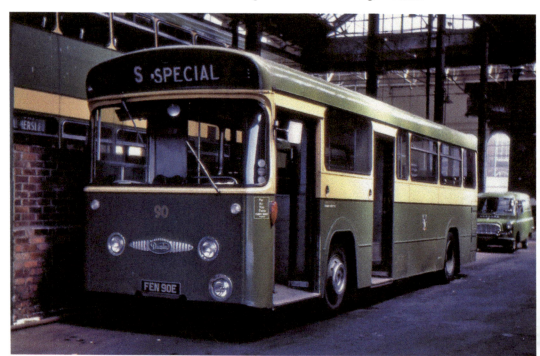

90 FEN 90E. The Rochdale Road depot was closed and demolished in 1985.

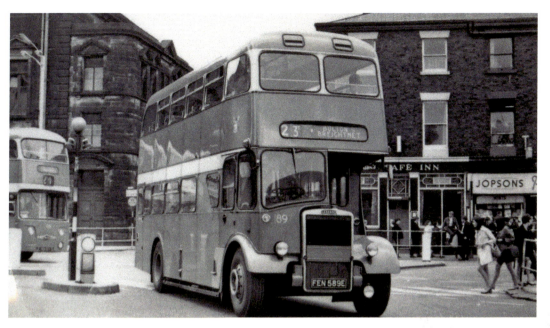

In 1967, the Corporation made a brief return to buying front-engined Leyland DDs. Four PD2/37s are seen here with the now-preferred East Lancashire bodywork. They were bought due to a weight restriction on Trinity Street Bridge in Bolton. The fleet numbers 187–90 followed on from the last PD 2s, which were new in 1953.

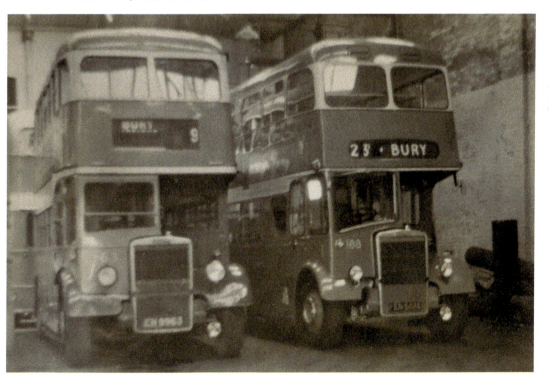

Fleet No. 188 has just been delivered in this image taken on 8 June 1967.

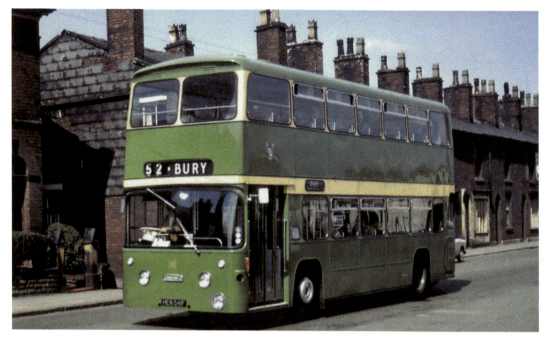

The last new double-deck Daimler Fleetlines to be delivered to Bury Corporation Transport (but not the last to be ordered) were six in May 1968. Again, with bodywork by East Lancashire Coachbuilders but built to East Lancs' new standard design for all rear-engine double-deck buses. 141 HEN 541F is seen here passing through Radcliffe on the 52 service from Bolton.

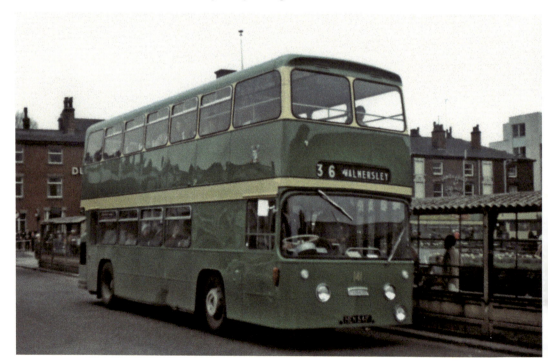

The same bus, this time on the 36 to Walmersley, in October 1968.

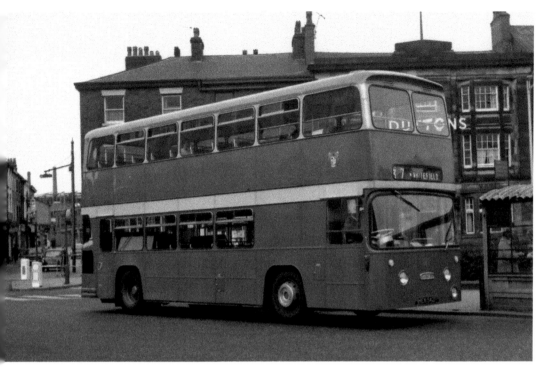

141 HEN 542F at Kay Gardens. This style of East Lancs bodywork was a popular choice on all makes of rear-engine chassis and was built for a wide selection of UK customers.

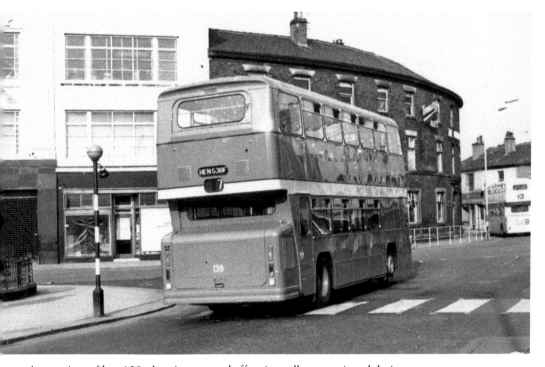

A rear view of bus 138, showing to good effect its well-proportioned design.

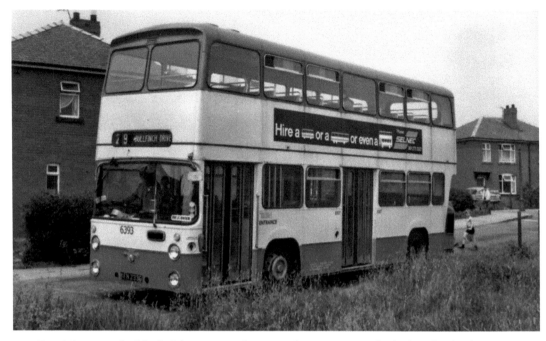

Bury's last new double-deck buses were three two-door East Lancs-bodied Leyland Atlanteans. They introduced a short-lived new livery of more cream and less green – both colours in a lighter shade. This view on Bullfinch Drive shows KEN 233G complete with its SELNEC fleet number, 6393.

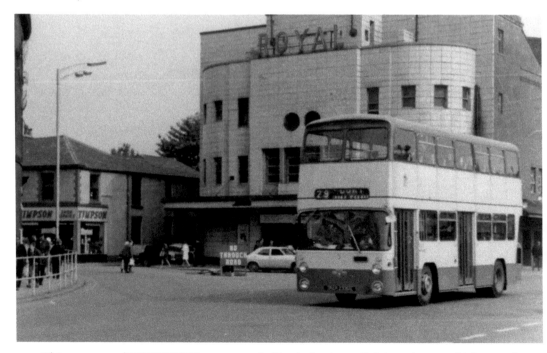

This area around 3 KEN 233G is now occupied by the bus/metrolink interchange, which opened in 1980.

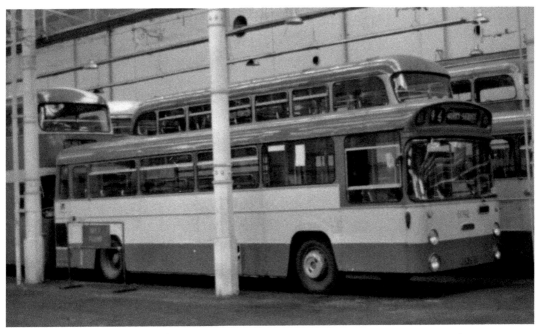

Six more East Lancs-bodied Daimler Fleetline single-deckers arrived in the spring of 1969. 92 KEN 292G is now fleet number 6092 when photographed here in the depot.

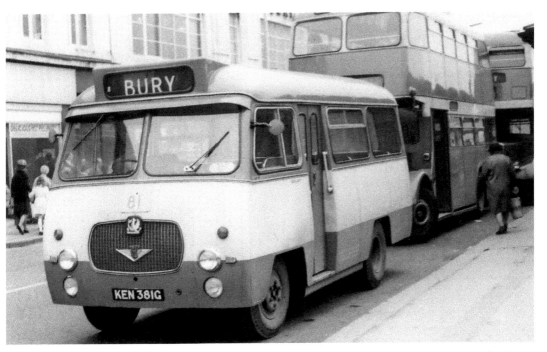

The last new bus delivered to Bury Corporation Transport was in July 1969. It was a radical departure from anything that had gone before. Numbered 81 KEN 381G, it was a Bedford J2SZ with twenty-one-seat Duple Midland bodywork. It was bought for the light-loaded 32 Chesham Road service.

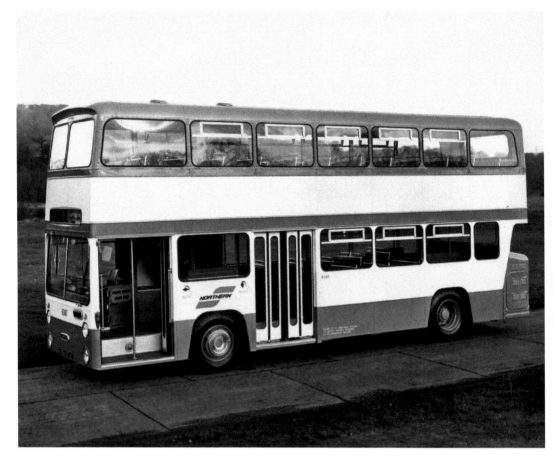

When SELNEC PTE was created on 1 November 1969, it took control overnight of eleven Lancashire and Cheshires, including here at BCT. At that time Bury had an outstanding order for twelve double-deck Daimler Fleetlines. The first seven, including this one, 6347 NEN 507J, started to arrive in December 1970. They had Bury registration numbers and green interiors, but were painted in the SELNEC livery of Sunglow Orange and Mancunian White, complete with appropriate fleet numbers. The remaining five came in 1972 and became part of a batch of twenty-one prototypes bodied by Northern Counties of Wigan.

MCW-bodied Leyland Atlantean 106 REN 106 waits its turn in the bus wash. PD3 208 is the next in line.

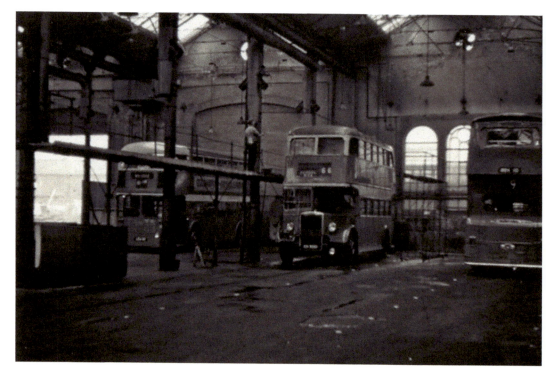

Guy Wulfrunian 101, Weymann PD2 162 and Atlantean 110 stand together in a near-empty Rochdale Road depot in September 1963.

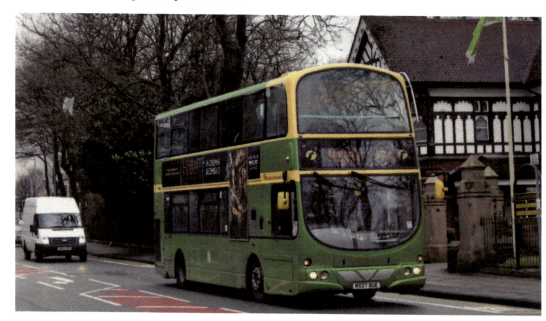

To celebrate its history, First Manchester painted eight buses in 2013 in the appropriate liveries – Bolton, Bury, Lancashire United, Manchester, Oldham, Ramsbottom and Salford. Bury's example was 2007 Wrights Gemini Volvo B9TL 37297 MX07 BUE. It was painted in the style of the 1958 Weymann-bodied Leyland PD3/6 with the cream front dome.

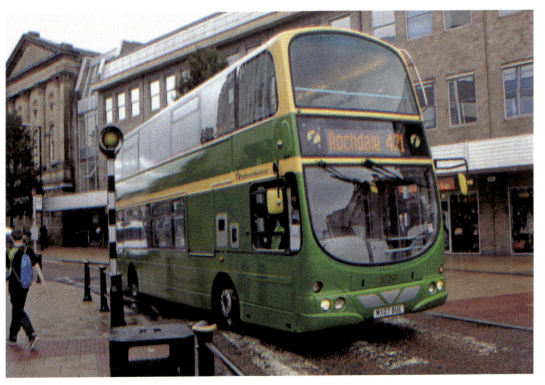

The same bus close to the bus/metrolink interchange in 2014.

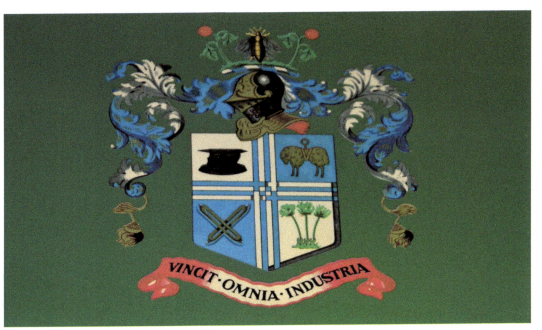

This is the coat of arms displayed on all Bury Corporation Transport vehicles. The four symbols represent the four main local industries at the beginning of the twentieth century – iron, wool, cotton and paper.

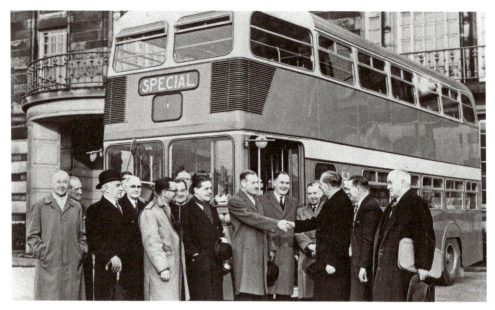

In this December 1960 view outside Bury Town Hall we see a special ceremony of the official handover of Guy Wulfrunian. We see members of the Transport Committee, who sanctioned its purchase (not one of its finest moments) along with representatives of both Guy Motors of Wolverhampton and Leeds-based coachbuilder Charles Roe. This bus had one of the shortest stays in service of any new Bury bus – just three years before it was sold.

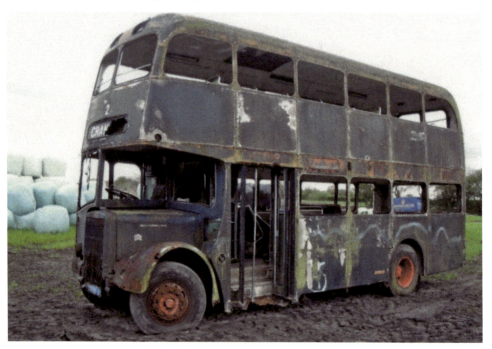

The donor bus fleet number 190, which had been stored on a remote farm for nearly fourteen years, would provide valuable spare parts for BCT 1967 East Lancs-bodied Leyland PD2/37 188 FEN 188E.

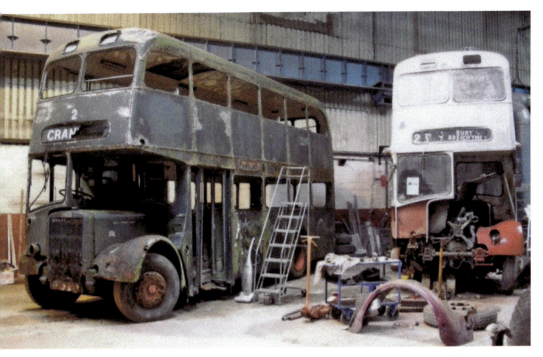

188, along with donor bus 190, is undergoing restoration in a former engineering factory on Crompton Way, Bolton, in May 2010. The author was employed at that factory for thirteen years from 1986.

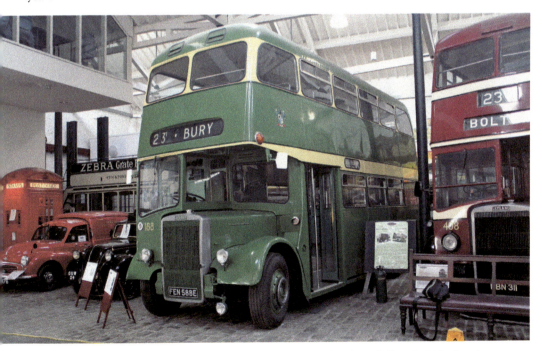

Leyland Titan PD2/37 East Lancs H3728FD 188 FEN 588E has been fully refurbished and now resides in the Bury Transport Museum, which forms part of the East Lancashire Railway.

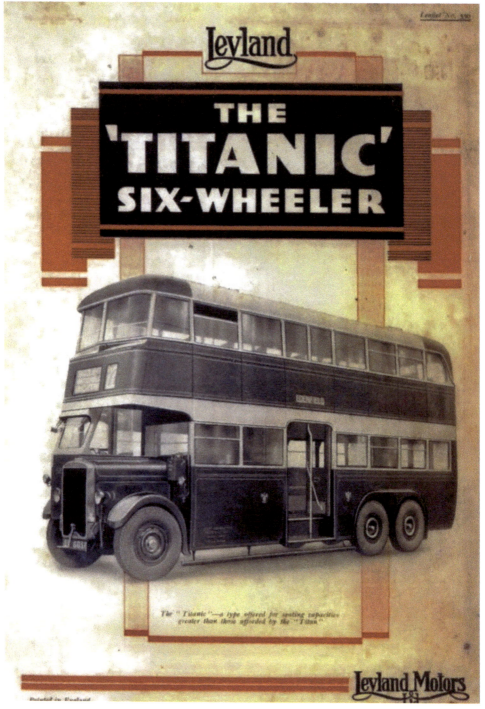

This is the cover of a 1935 Leyland Motors leaflet; an image of a Bury Corporation Titanic TT2 with English Electric bodywork.

BURY CORPORATION TRANSPORT

OFFICIAL
Time Table

JANUARY
1958
until further notice

PRICE 3d.

TRANSPORT OFFICES, MARKET PLACE, BURY

F. THORP, A.M.I.Mech.E.,
General Manager and Engineer

TELEPHONE BURY 2551-2552

This is the front cover of a timetable booklet dated January 1958.

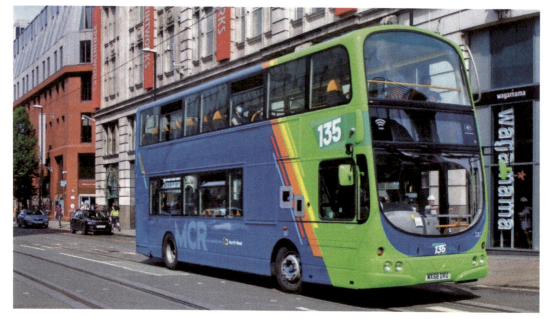

Go-North West, which operates out of Queens Road depot in Manchester, have painted all the Volvo B9TL Wrights Gemini double-deckers allocated to the 135 Bury–Manchester service in this route-branded livery. I wonder where the idea of the green fronts came from.

Another view of the 1969 delivery of East Lancs-bodied Leyland Atlanteans. 1 KEN 231G is seen in Bolton bus station when new on the service 52 back to Bury.

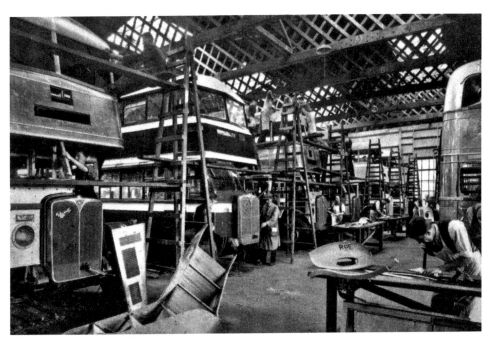

This view is taken inside the factory of Leeds coachbuilder Charles Roe sometime in 1933. Second from the left is one of Bury Corporation's eight AEC Regents under construction.

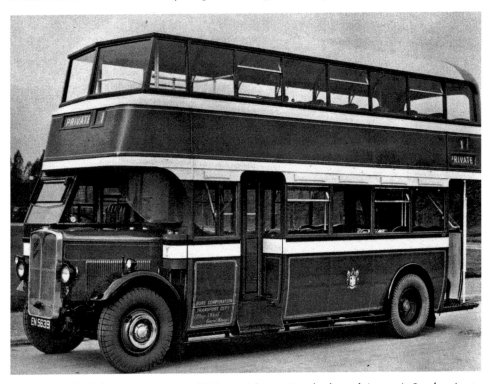

46 EN 5639 dual-door AEC Regent with forty-eight-seat Roe bodywork is seen in Leeds prior to delivery to the customer in October 1933.

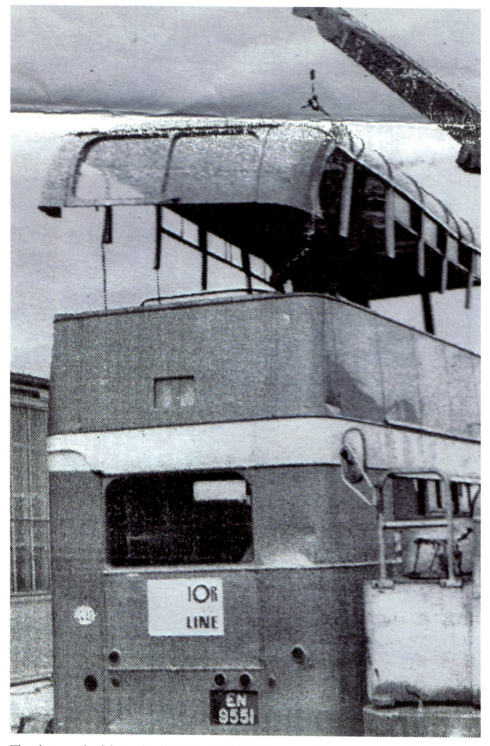

The photograph of the Leyland PD2/4 151 EN 9551 on page **45**, minus its roof. This view taken in Germany shows the roof about to be removed.